Joy

WEAVING

CONTEMPORARY MAKERS
ON THE LOOM

KATIE TREGGIDEN

LUDION

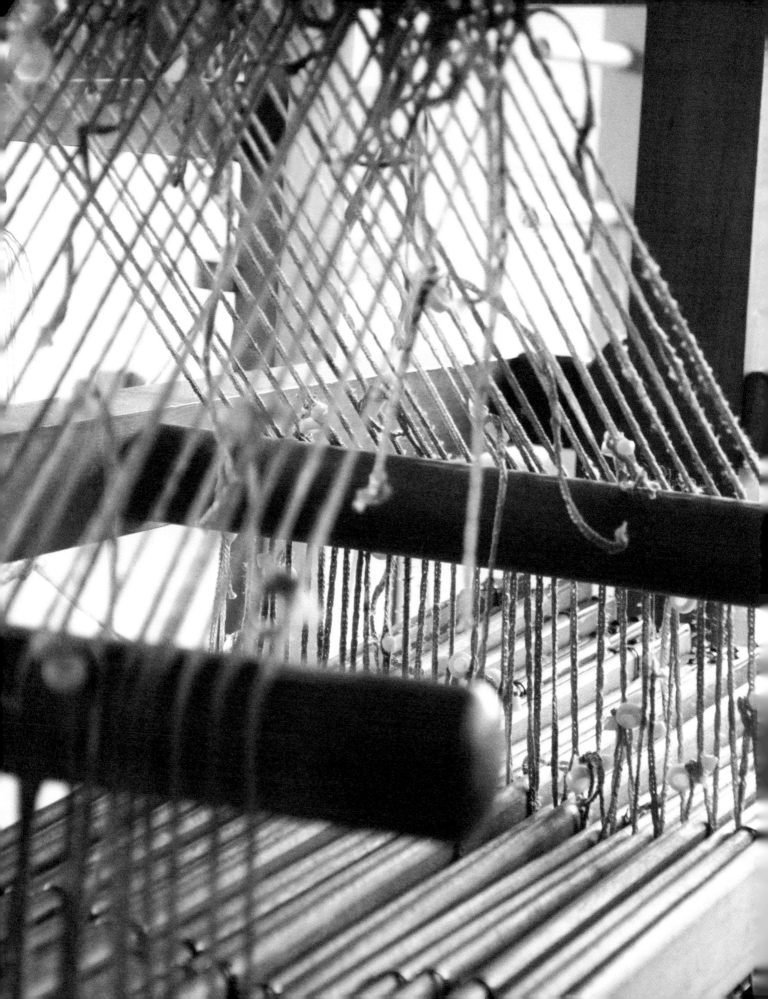

INTRODUCING
WARP AND WEFT

5 Weaving is a vast and complex subject about which many books have already
been written, from instructive how-to guides to seminal texts such as Anni
Albers' *On Weaving*. This book attempts to be neither, but perhaps something
in between – a survey of the contemporary weaving scene and an exploration
of some of the themes that touch the lives of makers today. In selecting both
weavers and topics, it has of course been necessary to leave many more
out than could ever have been included and those decisions have not been
taken lightly. It is the hope of both author and publisher that what has been
included will serve as an invitation for those new to weaving to go and find
out more, and perhaps provide some fresh perspectives for those already
familiar with the subject.

The history of weaving can be seen as a tug-of-war between hand and
head, between control and speed, between risk and certainty. Craft theorist
David Pye described the making process as a continuum from the 'free
workmanship of risk', where the maker responds to materials and process
throughout, to the 'regulated workmanship of certainty',[1] where decisions are
finalised before making begins. Moving along the spectrum from total risk
to total certainty promises time savings, increased tooling and the transfer

1 Pye, D. (1968) *The Nature and Art of Workmanship*. Cambridge: Cambridge University Press: 18–19

⊕ Heddles and shafts

of control from the hands of the maker to the owner and programmer of the tools. In reality, very little sits at either extreme – most making happens somewhere in the middle, employing 'hand knowledge' and 'head knowledge' simultaneously.

Although the principles of weaving have barely changed since its inception some eight thousand years ago and the very nature of the discipline requires decisions to be taken before the intertwining of warp and weft can begin, as the millennia have passed mechanisation and industrialisation have moved weaving further and further towards Pye's workmanship of certainty. Despite this shift, the element of risk has never lost its allure, and weavers throughout history have sought ways to engage with the threads throughout the process – not least the contemporary weavers profiled in this book, many of whom use simple hand, floor and table looms to create intricate and often challenging works of art, craft and utility.

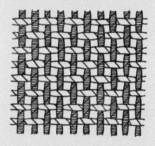

ill. 1
Warp and weft

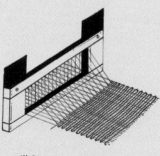

ill. 2
Shed

Fundamentally, weaving is the formation of a fabric through the interlacing of two sets of threads (the warp and the weft) at right angles to one another [ill. 1]. The warp threads are held parallel while the weft is passed over and under the warp in rows to create fabric. The process is as old as cloth; we have used fabrics to swaddle our newborns and wrap our dead since time immemorial. In fact it is likely that the weaving of textiles pre-dates the spinning of yarn, evolving from the practice of weaving reeds and grasses into baskets, fences and shelters. Very early weaving was carried out by hand, with one end of the warp tied onto clothing or a belt (in a process similar to 'finger-knitting') before looms were introduced to keep warp threads taut, enabling the weft to be interwoven more easily. From that point on, despite all its complexity, weaving has comprised three simple processes. First, a selection of the warp yarns (in the case of plain weaving, every other thread) is lifted to form a 'shed' – the wedge-shaped space between the warps that are

6

lifted and those left behind [ill. 2]. Second, the weft yarns (initially bundled together, later wound around a stick, and eventually wound around bobbins in a 'shuttle') are passed or propelled through the shed from one side to the other. Finally, the weft is beaten or 'tamped' towards the previous row with a comb, before the shed is changed (forming the 'countershed') with those warps that were lifted being lowered and vice versa, so the process can begin again in reverse.

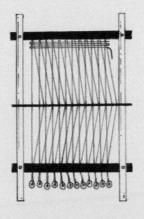

ill. 3
Warp-weighted loom

Early weaving used a 'warp-weighted loom', in which two wooden sticks are leant against a wall supporting a rotating upper bar from which warps are suspended, each one weighted at the bottom [ill. 3]. Weaving progressed downwards from the top, and so the weft was beaten upwards, working against gravity. Most commonly associated with Greek wool weaving (illustrations appear on Greek vases from 600 BC until 400 BC), this method was also used in Chilkat weavings common to several native communities on the northwestern coasts of North America – by the English in the early Bronze Age, in the rest of northern Europe until the Roman conquest, and in Scandinavia and Iceland until relatively recently.

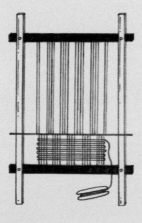

ill. 4
Two-bar vertical loom

The weights at the bottom of the warp were eventually replaced with a second bar, resulting in the two-bar vertical loom, which allowed weavers to weave upwards from the bottom and beat the weft downwards [ill. 4]. Examples of such looms appear in 12th Dynasty Egyptian wall paintings dating back to 1900 BC. They are still used by the indigenous Navajo people in the southwestern United States, as well as in Africa, Greece and the Middle East; they are similar to contemporary tapestry looms.

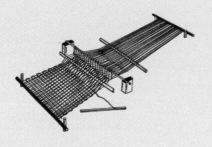

ill. 5
Egyptian ground loom

An alternative configuration is the Egyptian ground loom, also featuring two bars at each end of the warp but held horizontally off the ground by a peg at each corner [ill. 5]. These looms can be seen pictured on pre-Dynastic Egyptian pottery from 5000 BC to 3100 BC and were also used in Peru, India, Europe, Africa and what is now Turkey. The horizontal orientation suits finer and looser fibres and the fact that these looms are easy to dismantle and reassemble made this method of weaving particularly appealing to the Bedouin and other nomadic tribes in the Middle East, Pakistan and North Africa.

ill. 6
Back-strap loom

In the 'back-strap' or 'body-tension loom', the upper bar is attached to a pole or tree and the lower bar to a belt around the weaver's back, so the warp can be tightened or loosened as the weaver leans backwards or forwards [ill. 6]. Examples of the back-strap loom have been recorded in Asia, Japan, the Malay Islands, China, Myanmar and Tibet and they are still used in South and Central America – notably in Peru, Guatemala and Mexico.

8

As looms developed, so did the tools used with them – from the bobbins and shuttles used to propel the weft, to the combs, reeds and 'weavers swords' used to beat it down, but none was as influential as the 'heddle rod' or 'shaft'.

The design of a fabric is determined by which warp threads the weaver chooses to lift and which are left behind, determining which warps the weft passes under or over. This selection was once done by hand, giving the weaver full control – but this process took time, as the weft literally had to be moved handful by handful. The separation of warps was simplified by placing a 'shed rod' under the warps to be lifted; however this didn't solve the problem of raising the alternate warp threads to create the countershed. To address it, loose

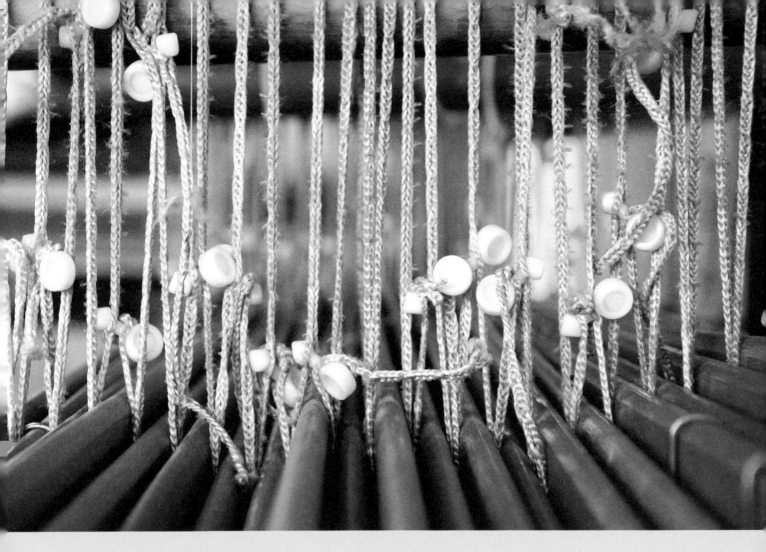

loops around these warp threads, called 'heddles', were attached to a rod above (the 'heddle rod' or 'shaft'). When this was lifted the threads were separated in the opposite way. A second heddle rod eventually replaced the shed rod, and multiple heddles were added to enable structural patterns, as seen in today's shaft looms. The introduction of heddles (first recorded in Egypt in 2000 BC but invented independently at different times around the world) was instrumental in the mechanisation of weaving.

For all the advances in speed and consistency that these tools brought, each new tool limited the freedom of the weaver. In a bid to regain control and return to the 'workmanship of risk', silk weavers in China in the 2nd century BC and in the Middle East in the 6th and 7th centuries AD

⊕ Heddles and lower shaft

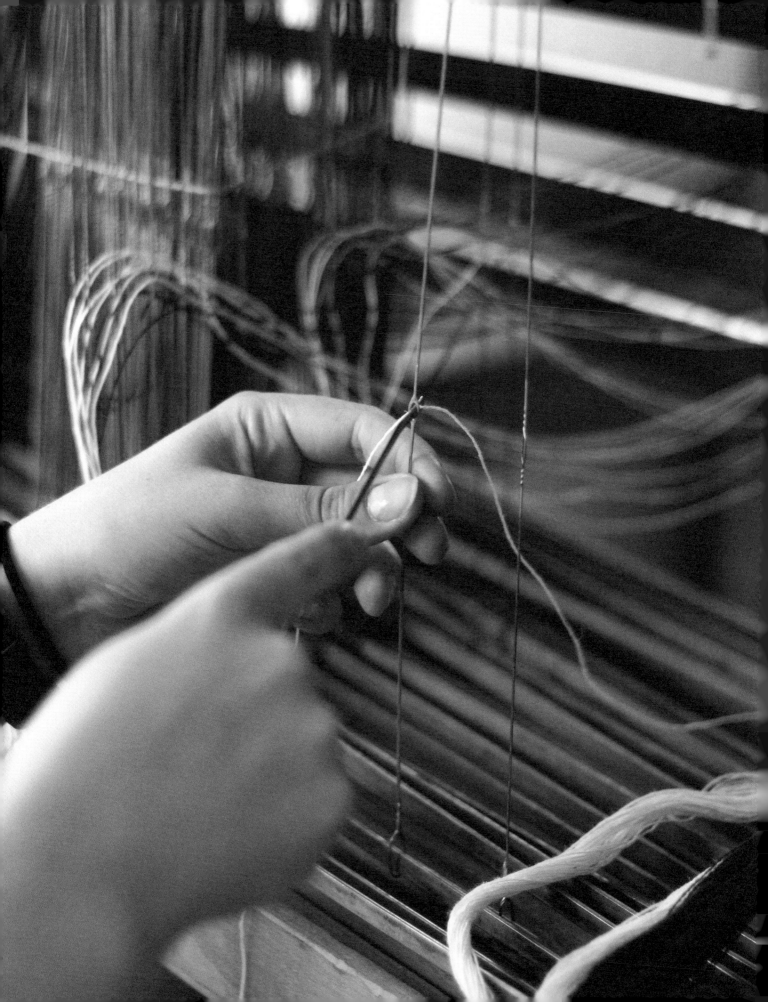

ill. 7
Draw loom

introduced the 'draw-loom', which enabled more elaborate patterns, such as brocaded textiles and damasks, by making an almost infinite number of different shed configurations possible [ill. 7]. Each warp was now attached to a heddle and the heddles were in turn attached to draw cords for every shed configuration the weaver wanted to use. Each shed had a numbered cord that was pulled in sequence by a 'draw boy' while the weaver inserted the weft. The number of sheds was limited only by the number of ways in which the draw cords would be combined. However, the size and complexity of the loom demanded skilled workers and a permanent set-up, so although this gave control back to individual weavers, the organisation of labour that the loom demanded meant they were rarely working autonomously.

11

Hand-weavers, who pass the weft thread through the shed from one hand to the other, could only weave fabric as wide as their arm span, until John Kay patented the 'flying shuttle' in 1733. This device enabled the weaver to propel their weft yarn through the shed along a system of cords at considerable speed. Combined with innovations in spinning, flying shuttles were one of the key developments that led to power looms and helped weaving to fuel the Industrial Revolution in the north of England and beyond.

The draw loom was used across Europe until it was superseded by Jacquard techniques in the early 19th century. In 1804, Joseph Marie Charles (known as 'Jacquard' after his father Jean Charles) invented an adaption to existing power looms through which a system of up to two thousand punch-cards dictated the shed configurations and therefore the patterns woven. 'Bolus hooks' attached to warp threads via a harness were either raised or stopped, depending on whether they hit the punch-card where there was a hole or where there was solid card. Whether or not each warp was raised or lowered determined whether the weft passed above or below it and therefore dictated the pattern. Each hook lifted individual threads, enabling intricate patterns to be made, and could also be attached to multiple threads, enabling the pattern to repeat across the fabric. This revolutionised the production

of highly decorative woven materials because, at a time when water and steam power were being introduced alongside technology that eliminated the need for draw boys and skilled weavers, it enabled the shuttle to be propelled mechanically, and eventually digitally. However, although Jacquard techniques represented a significant advance in technology, the cost involved meant that they were – and still are – reserved for expensive fabrics. The majority of woven fabrics, both then and now, are made on 'dobby looms' – a type of floor loom that uses a 'dobby' head ('dobby' is a replacement for and corruption of 'draw boy') to control the warp threads. Most have eight shafts or heddle rods, enabling them to lift groups of warps (as opposed to the single yarns lifted in Jacquard looms). An alternative is the treadle loom, where multiple heddle rods (shafts) are controlled by foot treadles – one for each heddle rod.

The weavers profiled in this book use both Jacquard and dobby looms, with some working on simple lap looms, representing work right across Pye's spectrum and embracing risk and certainty in different ways and at different moments in the process.

⊕ Dobby loom with dobby head

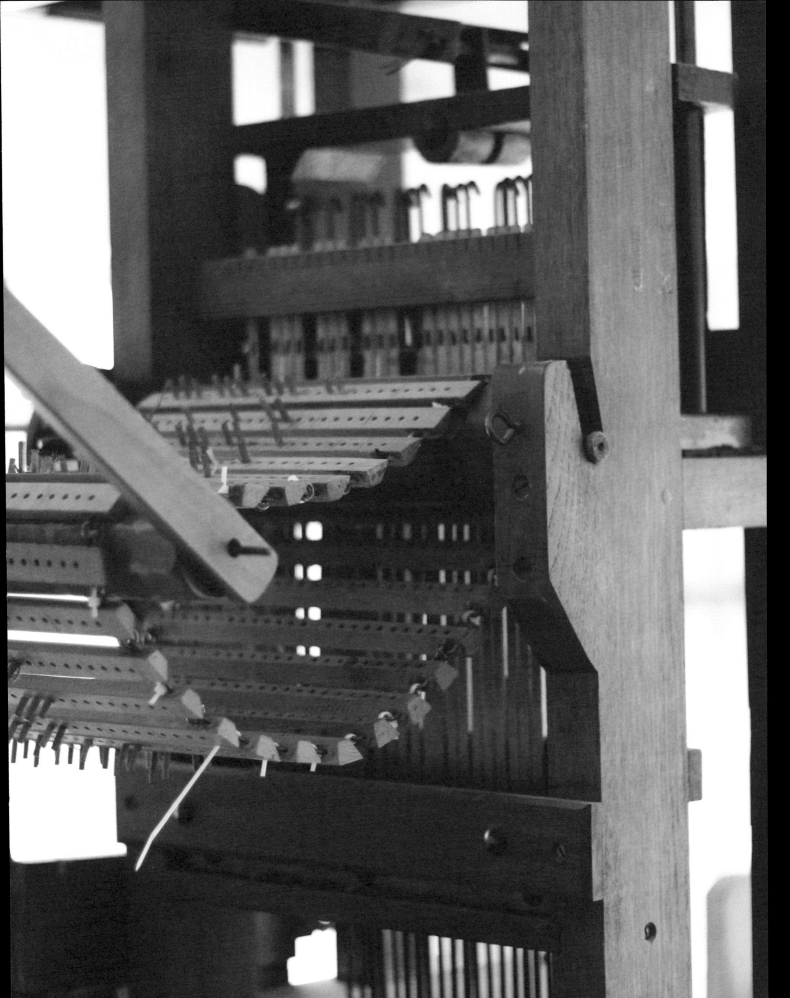

DEE CLEMENTS

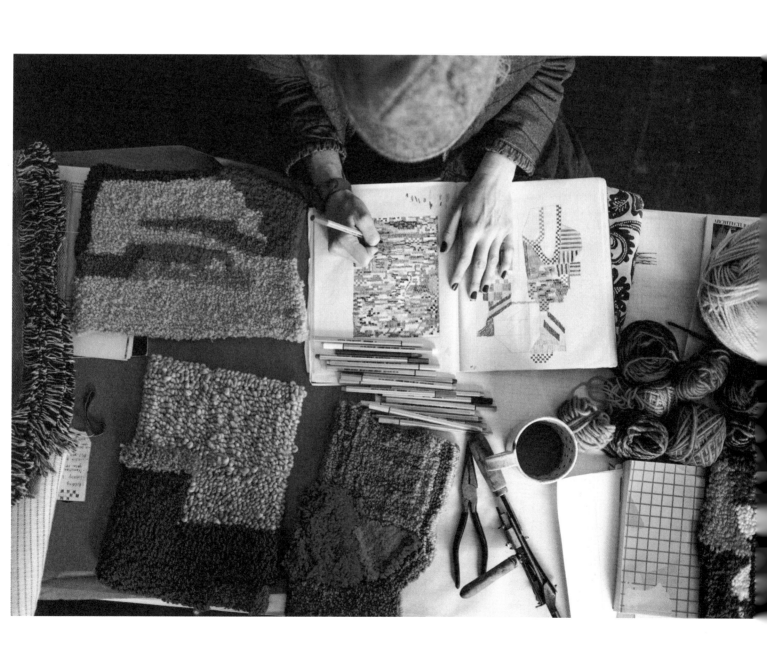

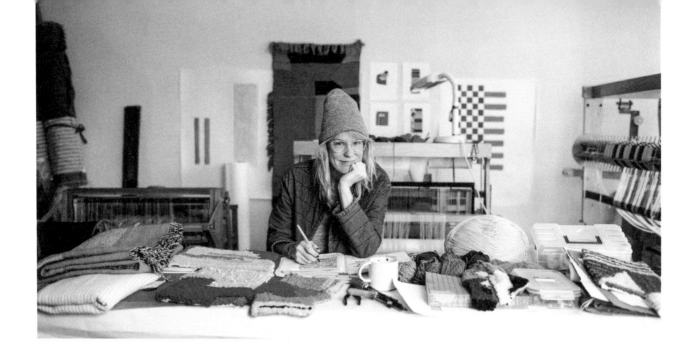

Dee Clements (New York State, United States, 1980) describes her work as 'conceptual functionalism', explaining that its purpose is to 'create joy, wellbeing and a deeper understanding of the relationship between art, craft and design'. Having completed residencies in Peru, Iceland, India and Scotland, she is just as likely to be inspired by the symbolic and multifunctional Berber rugs made by the nomadic Aït Bou Ichaouen tribe as by Kayla Mattes' woven pizza slices (see p. 202). 'Many cultures appropriate craft into daily life seamlessly, something I call the living arts,' she says. 'As an artist, I use textiles to explore the domestic. I am really interested in how manufacturing processes and craft techniques can be used to find an intersection between conceptualism and functionality.' Using a floor loom and a tufting gun, she makes textiles for the home, such as rugs and blankets, as well as sculptures and wall hangings.

Clements has been weaving for 16 years, but it was far from her first love. Having spent four years studying sculpture at the School of the Art Institute of Chicago (SAIC), she was used to harder materials such as metal and ceramics, so was keen to explore textiles – but not weaving, which seemed to her 'slow and boring'. One day her professor set up a 'round-robin warp' on the loom, enabling the whole class to make one continuous piece. 'I made a big stink about not wanting to try it – I was the last person to have a go,' she says. 'I walked into the weaving studio, sat down at the loom and, before I knew it, I couldn't stop. I loved the feeling of building something from scratch, thread by thread.' She dropped out of her sculpture course and completed her degree, majoring in fibre and materials studies.

Describing herself as 'material-curious', Clements has developed relationships with fibre farmers, dyers, mills and distributors all over the world. 'My work is so process based that sourcing high-quality materials is crucial,' she says.

Drawing, painting and model-making, together with digital rendering, all play roles in her creative process, but despite her initial reluctance it is from weaving that she derives the most pleasure. 'Sitting at the loom is where I find myself the happiest and most fulfilled.'

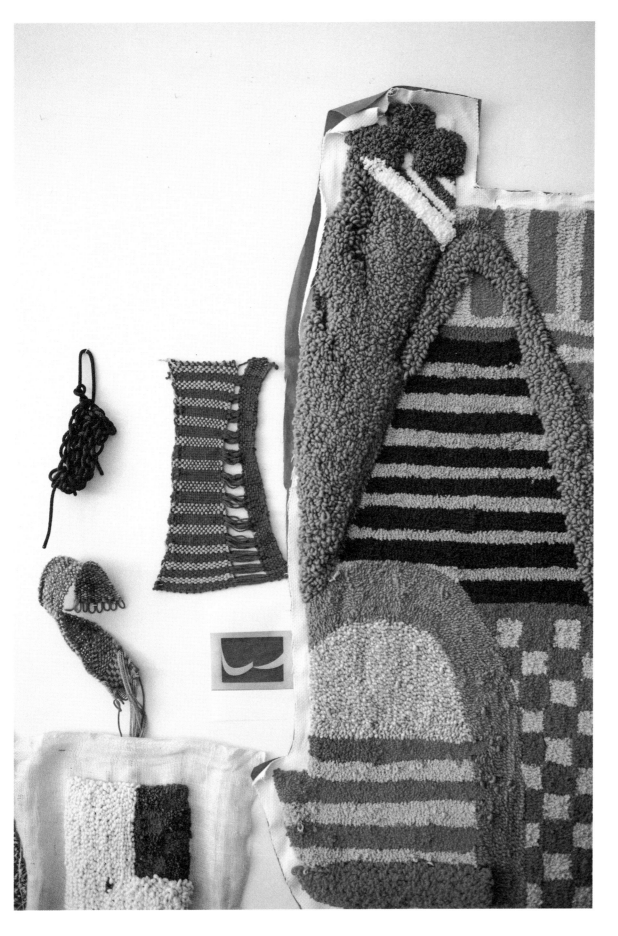

I have never enjoyed warping or loom threading – it hurts my body and it's not creative. I enjoy the actual weaving the most. Sitting at the loom is where I find myself the happiest and most fulfilled.

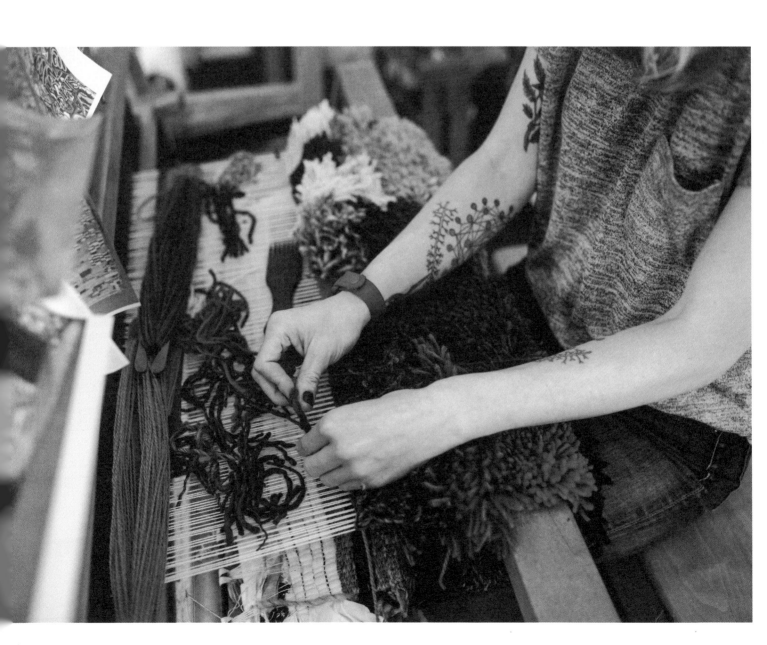

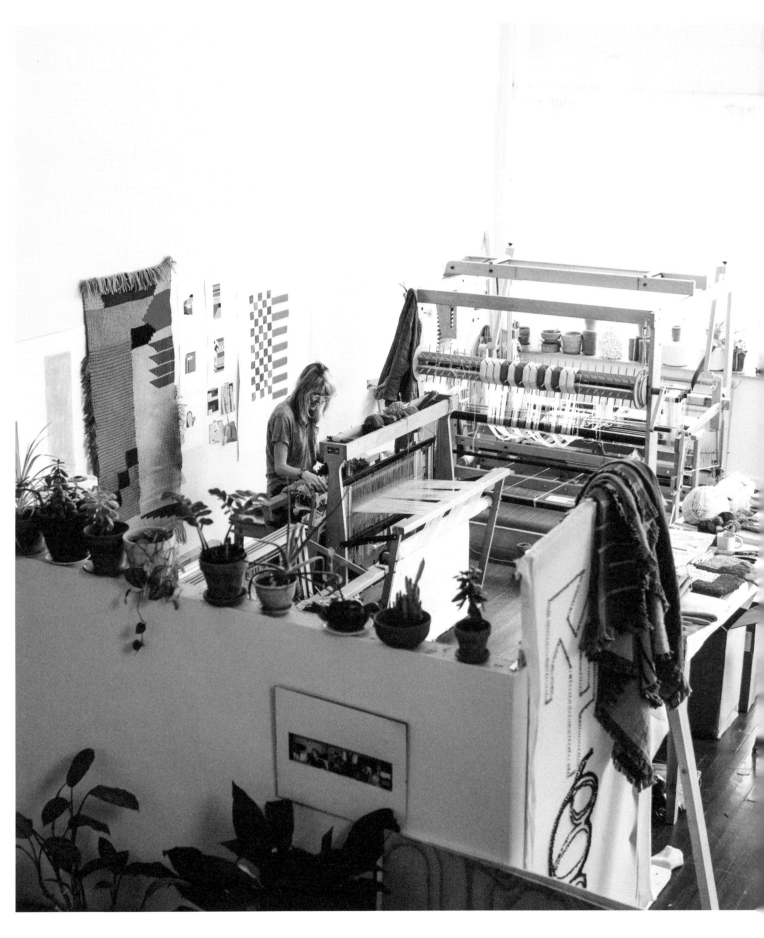

I don't consider myself a weaver, even though my work uses weaving and textiles, because there are so many other techniques involved, such as painting, drawing and sculpture. I prefer to be considered an artist and a designer who uses textiles as a medium. I love intricate, tedious work – it really lights up my brain. Perhaps that is why weaving struck such a chord with me.

DEE CLEMENTS

The idea that you have to make everything yourself by hand in order for it to be considered art is really limiting. I prefer the idea of widening the scope.

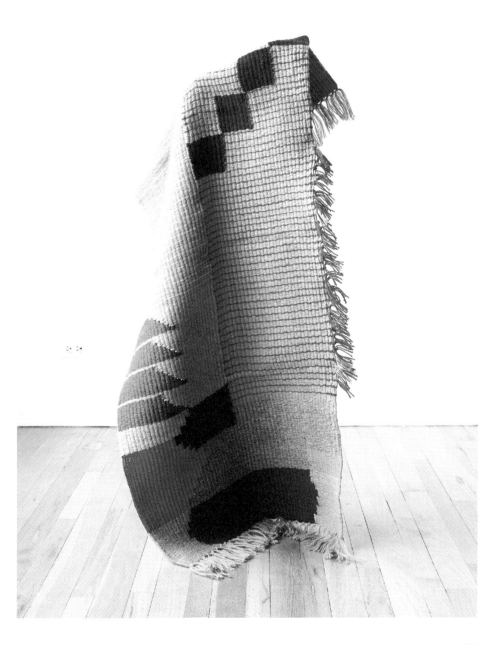

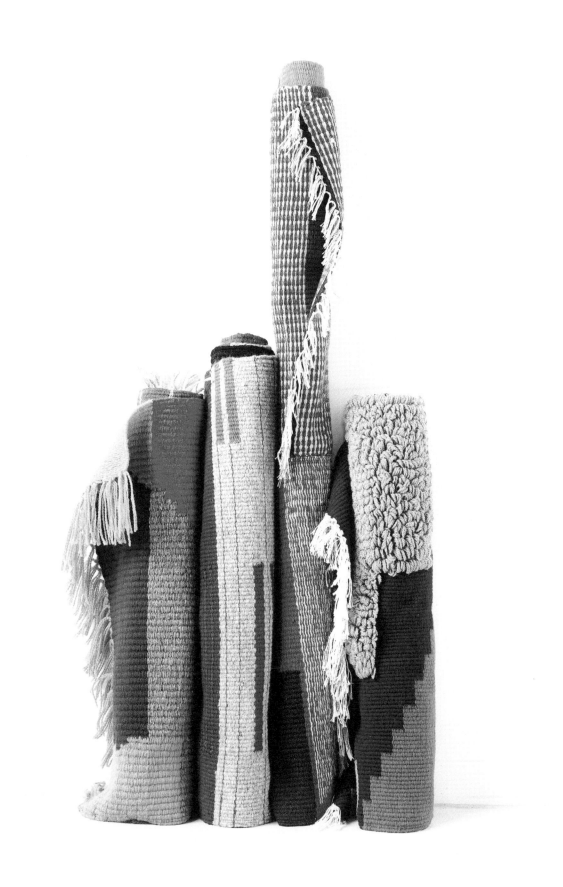

HIROKO TAKEDA

Although Hiroko Takeda (Tokyo, Japan, 1966) asked for a loom for her 10th birthday, her career in weaving was far from a foregone conclusion. 'When I was a child, I found a loom in a local toy store – I thought if I got it for my birthday, my life would be set,' says Takeda. 'My parents bought it for me and I jumped on it, but it was so hard to keep the selvedge straight, and I got frustrated and gave up.'

Weaving came back into her life while she was preparing for art school. 'One night, I snuck into a textile studio while visiting colleges – no one was around and everything was still,' she explains. 'I was struck by the sight of threads on the loom, midway to becoming fabric, and was fascinated straight away.' But again, she found the practice difficult and the time-consuming preparations put her off. However once she started weaving, she quickly found a way in. 'I started to enjoy changing the colour and structure while weaving. I thought, "Wow, weaving has depth, and so many possibilities."' She honed her craft at art school, following the 20th-century Mingei tradition, which emphasises the beauty of everyday objects made by unknown craftspeople. 'I wanted to study art, but I wanted to be a specialist,' she says. 'Whatever specialism I chose, I had a strong desire

to know and understand it.' She received intensive training in folk traditions and learned to wash and card fleece, and to spin yarn, as well as weaving and finishing. She deepened this knowledge with an apprenticeship in Kyoto, followed by eight years spent working in Kyoto and Tokyo for the same company, before undertaking a master's at London's Royal College of Art.

Winning a competition sponsored by American textiles brand Larsen led to a job in New York. When the practice relocated to Paris, she struck out on her own, taking one of Larsen's looms to a studio in Brooklyn, where she is based today. Her distinctive yet understated style is the result of a deep understanding of craft and materiality learned in her home country, combined with a more technical and conceptual approach developed in London and New York – but there is also something more: 'I would like my work to be soulful. The important thing for me is to put my soul into whatever I am working on.'

I approach my work as a painting or sculpture. I dye and mix threads, colours and textures to create a palette, combining and blending elements. I manipulate and orchestrate all factors and welcome accidental moments of material behaviour.

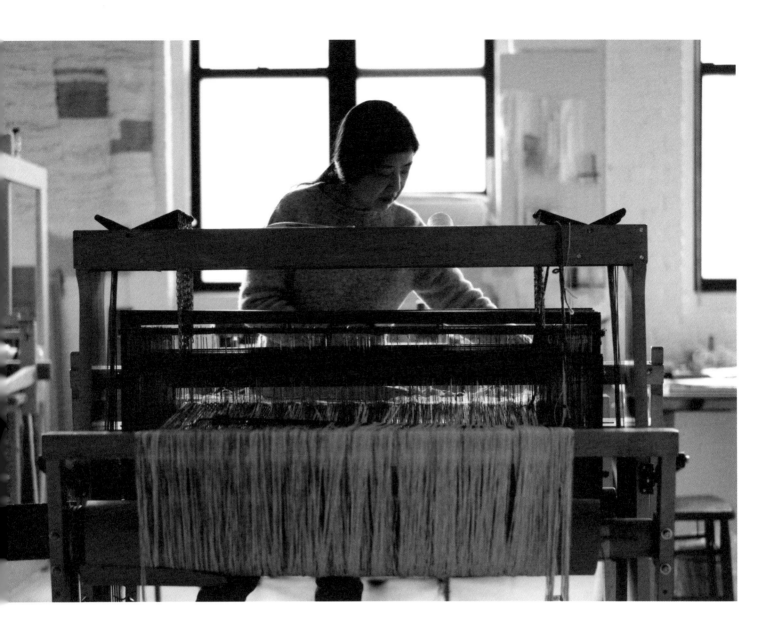

All of my work starts on the handloom in my studio. It is crucial for me to keep the legacy of the hand, even for work that I manufacture in a mill. I need to pass techniques I develop in my studio on to the mill – this type of transfer is an important part of my work.

HIROKO TAKEDA

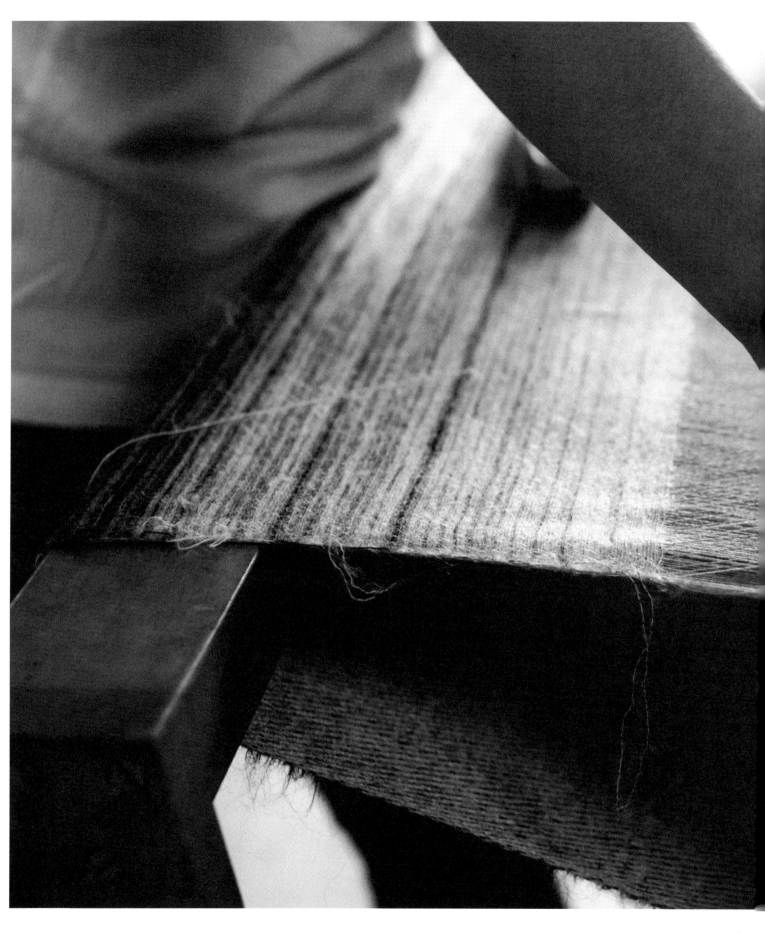

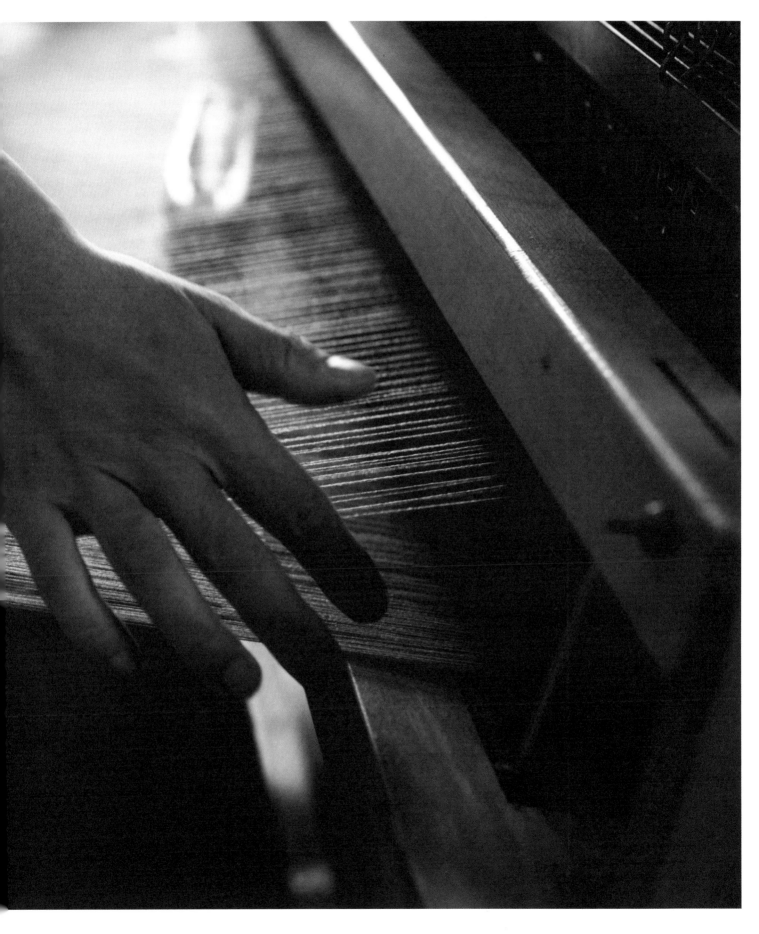

HIROKO TAKEDA

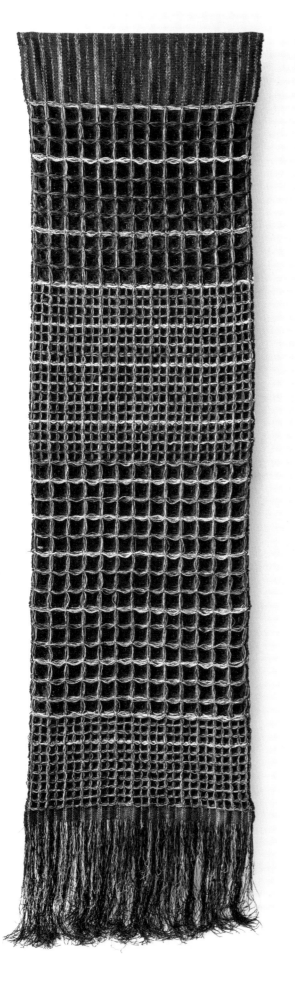

Some of my work is functional, such as site-specific draperies and wall coverings, but some is purely aesthetic, such as tapestries and free-hanging pieces. But its purpose is always to convey what I feel.

GENEVIEVE GRIFFITHS

Genevieve Griffiths (Hobart, Tasmania, 1981) trained as an architect and now fits weaving around her role as mother to two daughters. 'I am rarely alone when I weave – there is always a child or two at my feet,' she laughs. 'My 3-year-old has started to take an interest and works alongside me, but the majority of my weaving is done once the girls are in bed.'

Despite being a 'dedicated crafter' in childhood, Griffiths only started weaving in 2012 after seeing the work of Brooklyn-based artists New Friends. 'I was so inspired; I just had to give it a go,' she says. 'I made my first wild and very wonky weaving on a vintage loom from a second-hand shop, having watched a few online tutorials.' Excited by the possibilities, colours and textures of wool, her new hobby soon grew into a passion. 'It is a meditative outlet for my creativity,' she says. From those

'wild and wonky' beginnings she is starting to incorporate more planning into her work. 'I used to decide on the size and colour palette, warp my loom and take it from there in a pretty freehand way,' she says. 'With my current body of work, I am approaching things a little differently – doing a series of watercolour designs, cutting them up and moving elements around until I am happy. I intend to weave directly from these, but only time will tell how strictly I stick to that plan.'

Regardless of the process in between, it's the beginnings and the endings that energise this weaver. 'I love the excitement of warping my loom and imagining what it will become. The moment a piece is finished is immensely satisfying too – weavings relax a little when you release them from the loom, they become softer and more magical – it makes all the hard work in the middle worthwhile. I think the time and creative energy poured into a weaving stays with it long after it is finished.'

My loom is fairly portable so I tend to move it around. I don't have a studio as such, just a corner of the living room where I do most of my work. I also like to shift my loom to the deck and do some outdoor weaving from time to time. I am rarely alone when I weave – there is always a child or two at my feet.

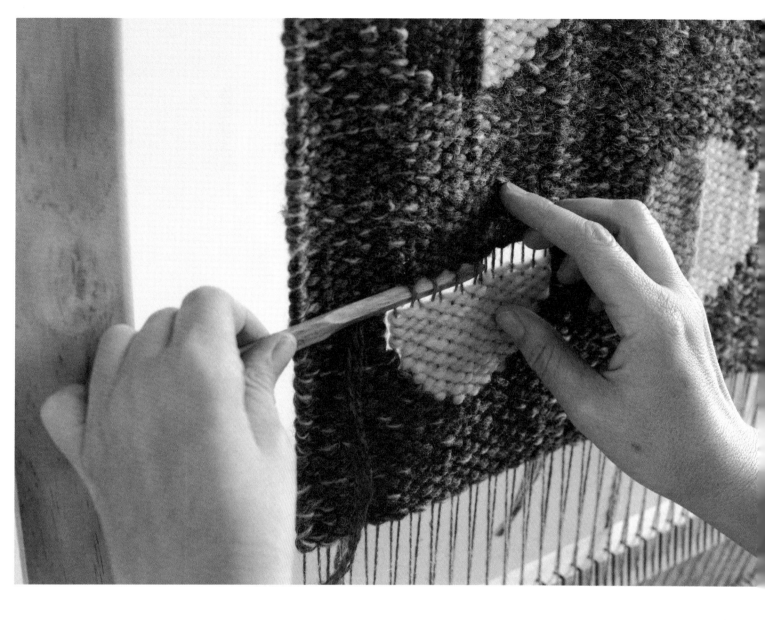

My favourite parts are the beginning and the end – I love the
excitement of warping my loom and imagining what it will
become. The moment a piece is finished is immensely satisfying
too – weavings relax a little when you release them from the loom,
they become softer and more magical – it makes all the hard work
in the middle worthwhile.

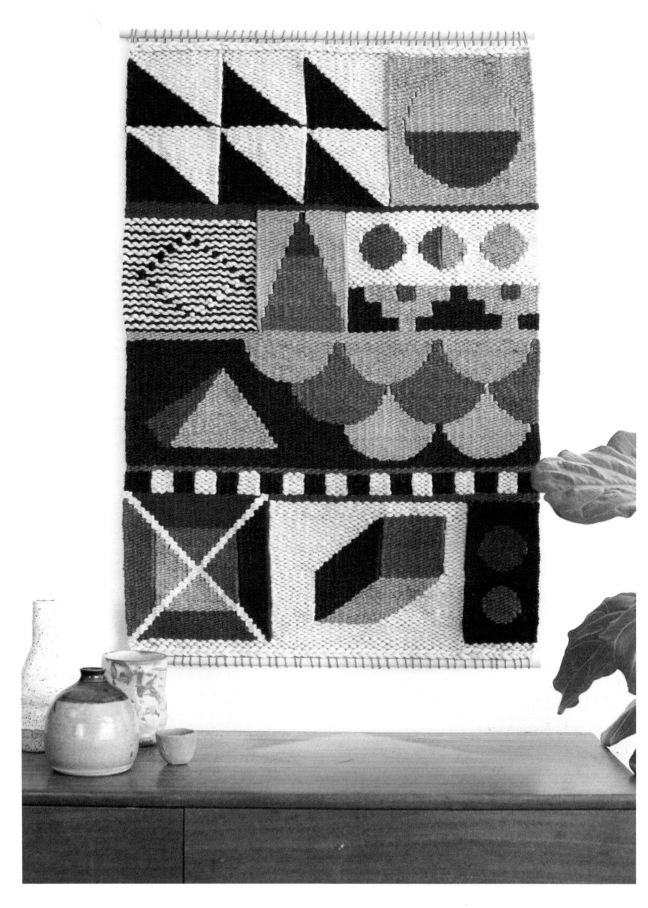

GENEVIEVE GRIFFITHS

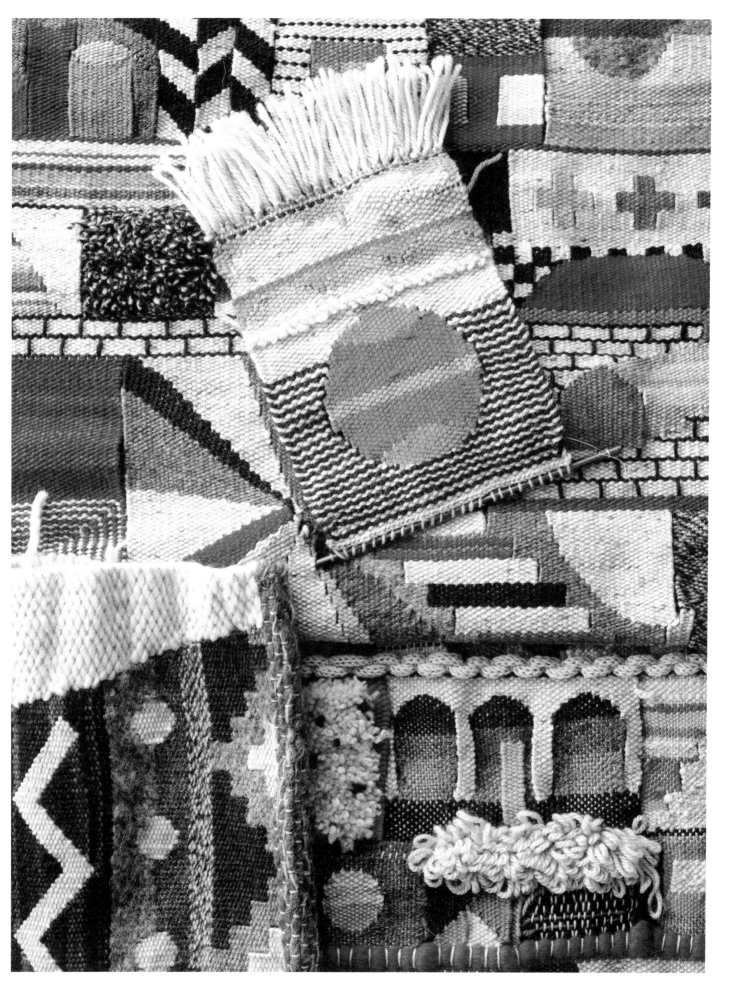

The tactility and uniqueness of handmade objects help to connect the maker and eventual owner to the world around them. The time and creative energy poured into weaving stay with each piece long after it is finished.

HERMINE VAN DIJCK

Hermine Van Dijck (Antwerp, Belgium, 1989) is a woman on a mission – firstly to protect and restore Belgium's weaving legacy. From the Middle-Ages until the Renaissance, the Southern Netherlands (modern-day Belgium) were renowned for their craftsmanship in weaving, but this proud history is in danger of being lost because Belgian weaving companies struggle to compete with mass production from the East. 'Weaving is a very important part of Belgium's cultural heritage,' Van Dijck says. 'I want to keep our heritage alive by working as locally as possible. If everyone did the same, we could guarantee the future of weaving in Belgium.'

But it's not just national interests that drive her; she is also concerned about the environment and the fate of the sheep that provide her yarn. She only uses natural yarns and prefers those with Global Organic Textile Standard (GOTS) certification, which guarantees they are made without toxins or animal cruelty. She also tries to reduce waste by using yarn that would otherwise be thrown away. 'I want to fight for a sustainable textile industry, so I buy unwanted yarn from Belgian weave enterprises,' she says. 'I really believe that small companies can make the difference.'

Van Dijck even managed to source her looms with the same ethos – her 16-shaft table-loom was made by a woodworker in Antwerp and her 8-shaft Scandinavian countermarch loom was being thrown away by a textile school in the Netherlands. 'It's such a lovely thought that in the city where I work there is someone creating looms,' she says. 'It also makes me really happy that I was able to save the Scandinavian loom and give it a new life in my workspace.'

It comes as no surprise that the primary motivation for Van Dijck's tactile blankets and accessories is to bring people joy. 'Joy through colour, through texture and through love – love for the making process, and love for the fibre,' she explains. 'The first time I saw people weaving, I was so overwhelmed by the beauty of the technique, the magic of the yarns, and the slowness of the movement that I knew that it was something I would treasure for the rest of my life – a *coup de foudre*, as we say in French. I hope to inspire other people to fight for their dreams to become weavers.'

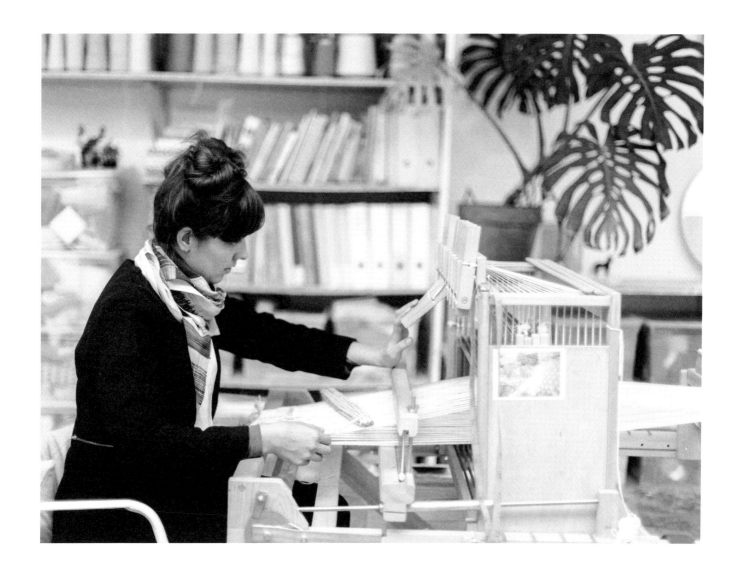

My first weaving experience immediately made me dream about all the possibilities of the craft. But it took me several years before I truly understood the process. My weaving teacher, who is in her sixties, told me that one human life isn't enough to explore all the possibilities of weaving and that she is still learning every day.

HERMINE VAN DIJCK

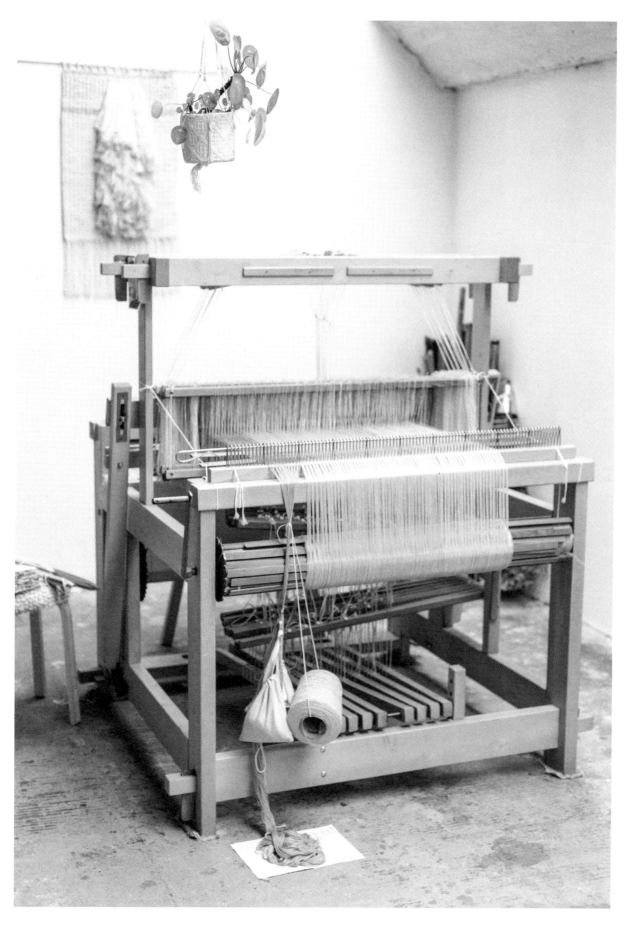

The process of preparing the warp and threading the loom can take up to three days, depending on the size of the yarn. It is a process that requires a lot of patience, but I adore the slowness – the simple repetition of the movement makes me calm and happy.

I would describe my work as poetic textiles. I combine the artisanal character of old weaving techniques with modern aesthetics. The work I make is unique for its colour combinations and I always use natural fibres with lovely textures. My weavings are little treasures for the home.

HERMINE VAN DIJCK

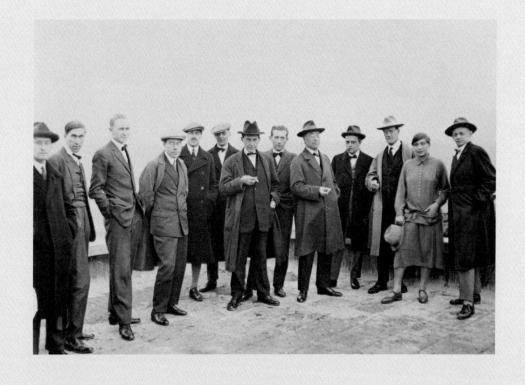

WEAVING GENDER

'Unravelling gender [is] not dissimilar to the weaver who, unpicking
a fault in the cloth, neatly has to disentangle warp from weft.'
— SCHWARZKOPF, J.D.[1]

49 A black and white photograph of the Bauhaus masters on the roof of their
Dessau building presents a veritable who's who of Modernism. Among the
suited gentlemen are László Moholy-Nagy, Walter Gropius and Wassily
Kandinsky – all well renowned today. There is just one woman in the
group. Standing second from the right is Gunta Stölzl, head of the weaving
workshop and the only woman ever to achieve master status at the Bauhaus.

Although weaving has been a craft 'reserved for women'[2] since early societies,
it was initially a high-prestige pursuit that earned weavers public respect
– craft was seen as the 'civiliser' of hunter-gatherer tribes.[3] However, by the
time Aristotle was writing *Metaphysics*, a hierarchy was emerging:

> We consider that the architects in every profession are more
> estimable and know more and are wiser than the artisans,
> because they know the reasons for the things which are done.[4]

1 Schwarzkopf, J.D. (2004) *Unpicking Gender : The Social Construction of Gender in the Lancashire Cotton
Weaving Industry, 1880–1914.* Abingdon: Ashgate Publishing Ltd: 1

2 Sennett, R. (2008) *The Craftsman.* London: Penguin Books: 23

3 Ibid.

4 Ibid.

⊕ The Bauhaus masters on the roof of the new Bauhaus building, 1926. From left to right: Josef Albers, Hinnerk
Scheper, Georg Muche, László Moholy-Nagy, Herbert Bayer, Joost Schmidt, Walter Gropius, Marcel Breuer,
Wassily Kandinsky, Paul Klee, Lyonel Feininger, Gunta Stölzl, Oskar Schlemmer.

As well as placing architects above artisans, Aristotle uses the word *cheirotechnon* for the latter. It simply means 'handworker', in contrast to the earlier *demioergos*, which combines 'public' and 'productive' positioning craftspeople at the heart of the community. Although weaving still carried status – an annual ritual in Athens saw women parading their woven *peploi* through the city's streets – this hierarchy had begun to both devalue craft and separate the 'domestic craft' practised by women in their homes from the 'skilled craft' carried out by men in the public domain.[5] This was exacerbated by the organisation of skilled labour into guilds in the Middle Ages, membership of which was usually restricted to men – women continued to weave and occasionally became apprentices and even masters, but their presence was often masked in the records as they were listed under their husbands' or fathers' names.

This perception continued well into the 19th century, when the priority of 'draughtsmanship over craftsmanship'[6] positioned craftspeople between the designers and architects above them and the unskilled workers below, and the gender bias within craft continued. An account of the silk-weaving trade in London's Spitalfields states that 'A weaver generally has two looms, one for his wife and another for himself' – further evidence that women were weaving, but as wives rather than weavers in their own right, not getting the same public recognition as their husbands, who controlled the trade.

There were exceptional cases of gender equality in the public domain:

> In the heartland of the cotton-weaving district of Lancashire, men and women were working side by side, producing the same types of cloth on the same kind of machines. Moreover, these identical tasks were remunerated on the basis of identical piece rates, which varied, not with the gender of the worker, but with the type and quality of the cloth produced.[7]

5 Sennett, R. (2008) *The Craftsman.* London: Penguin Books: 23

6 Adamson, G. (2013) *The Invention of Craft.* London: Bloomsbury Academic: 20

7 Schwarzkopf, J.D. (2004) *Unpicking Gender: The Social Construction of Gender in the Lancashire Cotton Weaving Industry, 1880–1914.* Abingdon: Ashgate Publishing Ltd: 4

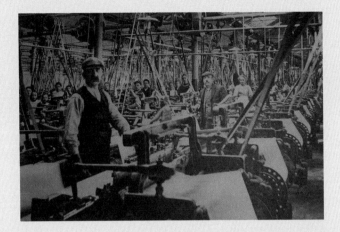

However, in the main, perceived gender stereotypes were reinforced by male spinners and weavers in collusion with factory owners. Certain machines such as the 'spinning mule'[8] were supposedly beyond the strength and skill of women (intended to be operated by men, they were therefore designed to suit them); whereas others such as the water-powered 'throstle' and its descendant the 'ring spinning machine'[9] were designed for and operated by women. This helped to ensure certain roles within the mill were seen as inherently masculine or feminine.

Despite the men's best efforts, the increasing reliance on water- and steam-powered machines soon dispensed with the need for muscle power, and women increasingly took over men's roles. Their new-found equality in labour encouraged first-wave feminists to fight for the vote, better working conditions and equal pay.

It was against this backdrop that Bauhaus founder Walter Gropius proclaimed: 'No difference between the beautiful and the strong sex, absolute equality,'[10] in his first speech in 1919. Female students outnumbered men 84

8 A machine used from the late 18th to the early 20th century in Lancashire mills to spin cotton and other fibres. Mules were worked primarily by a male operator with the help of two young boys.

9 Named for the noise it made, which sounded like a thrush, or 'throstle', this was a lighter machine used for the continuous spinning of cotton (or wool). The ring frame developed from the throstle frame – both use a continuous process, unlike mule spinning which requires an intermittent action.

10 Müller, U. (2009) *Bauhaus Women*. Paris: Flammarion: 9

⊕ Men and women working alongside one another in a Lancashire mill

to 79 in the school's first year. Early workshops were not gendered and a male student, albeit just one (Max Peiffer Watenphul), took part in weaving. Female student Gunta Stölzl thrived in the chaos of the early Bauhaus, trying her hand at different disciplines. But the equality was not to last. Concerned that the popularity of the school among female students would damage its credibility, Gropius quickly diverted female students into the weaving workshop, keeping them away from 'masculine' workshops such as metalwork or furniture that were seen as closely linked to the ultimate male domain: architecture.

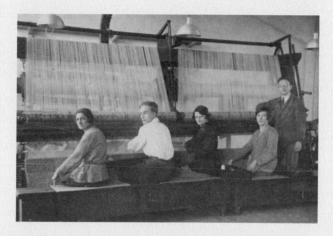

It wasn't just the structure of the school that was becoming gendered, the discourse of its leaders was too. Early 20th-century ideas around gender still associated men with culture and women with emotion. Gropius connected head knowledge with masculinity, and hand knowledge with femininity, Wassily Kandinsky postulated that both genius and creativity were inherently male, and Johannes Itten believed that women saw in two dimensions and should therefore only work with surfaces.[11] Painter and Bauhaus master Oskar Schlemmer said, 'Where there is wool, there is a woman who weaves, if only to pass the time,'[12] simultaneously feminising and belittling weaving.

11 Müller, U. (2009) *Bauhaus Women*. Paris: Flammarion: 10
12 Ibid.

⊕ Weaving workshop at the Bauhaus, Dessau, 1927
⊕ Wall hanging *Slit Tapestry Red-Green*, **Gunta Stölzl**, 1927–1928
Gobelin technique, cotton, silk, linen, 150 × 110 cm

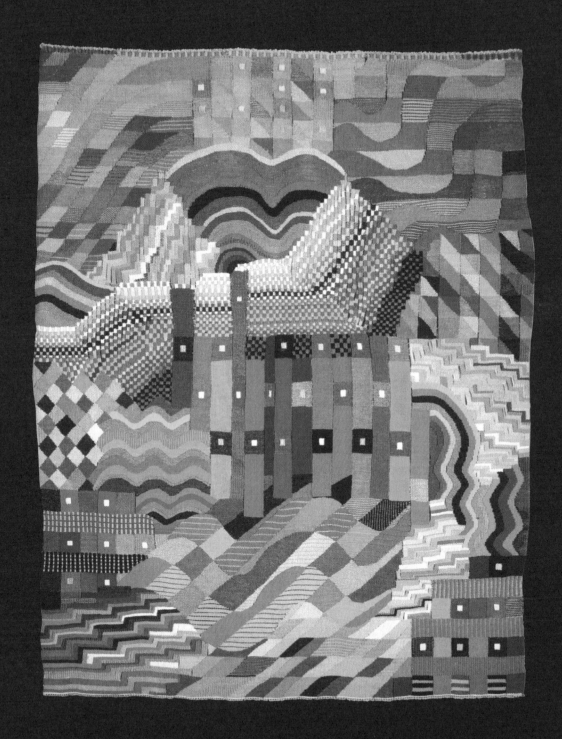

In the early days, the weaving workshop was run by Helene Börner, weaving workshop master at the Weimar Applied Arts School, from which the Bauhaus borrowed its looms. 'At the beginning we learnt nothing at all,'[13] wrote Stölzl's fellow student Anni Albers of those days. When Georg Muche took over in 1921, he swore never to 'weave a single thread, tie a single knot, make a single textile design',[14] so the students were largely left to their own devices. 'We sat there and simply tried things out,' said Albers. 'I learnt a lot from Gunta [Stölzl], who was a fantastic teacher.'[15] From this informal start, Stölzl became head of the weaving workshop in 1927 and eventually the school's only female master. She introduced a new syllabus focused on the development and theory of the craft and created commercially successful products that made weaving the school's most prosperous endeavour, giving the women who worked in it status and prestige within the school.

There are parallels today in rural Afghanistan, Iran and Turkey, where carpet weaving, mostly carried out by women, is an important source of income. Despite cultural conventions that prevent women leaving their villages, if not their homes, weaving rugs and carpets enables them to work, often becoming the main breadwinner for their family in areas with little other industry. Although money is handled through male relatives, their earning potential is starting to win them status within families, communities and wider social structures and slowly contributing to their empowerment.

Despite the prestige earned by both contemporary weavers and the women at the Bauhaus, it was and is still widely seen as 'women's work'. Art historian Glenn Adamson's side-by-side comparison of *Hanging*, a weaving designed by Albers and made by Stölzl with *Composition B (No.II) with Red*, a painting by Piet Mondrian, reveals the problem. He describes both pieces as 'self-consciously modern and superficially similar in style',[16] and the two objects either seem comparable or the fabric comes out on top, demonstrating additional functionality, skills or sensorial qualities, on every count. And yet, in conclusion, he says of Albers' and Stölzl's *Hanging*: 'As an object made

13 Müller, U. (2009) *Bauhaus Women*. Paris: Flammarion: 45

14 Smith, T. (2014) *Bauhaus Weaving Theory: From Feminine Craft to Mode of Design*. Minneapolis: University of Minnesota Press: XXVII–XXVIII

15 Müller, U. (2009) *Bauhaus Women*. Paris: Flammarion: 45

16 Adamson, G. (2007) *Thinking through Craft*. London / New York: Berg: 4–5

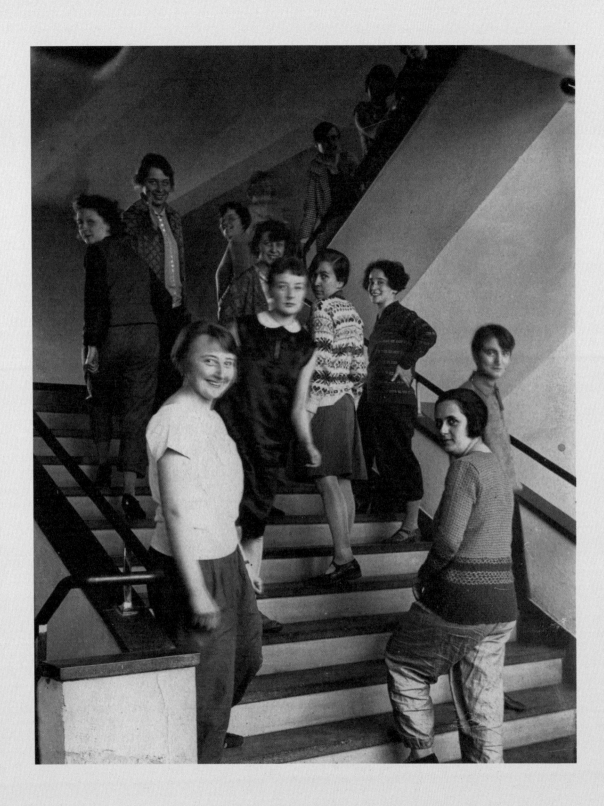

The weavers on the Bauhaus stairway, Dessau, 1927. From the top: Gunta Stölzl, Grete Reichardt, Lijuba Monastirsky, Otti Berger, Elisabeth Müller (bright-patterned pullover), Lis Beyer (middle, white collar), Rosa Berger (dark pullover), Lene Bergner (left), Ruth Hollos (right), Elisabeth Oestreicher (in front)

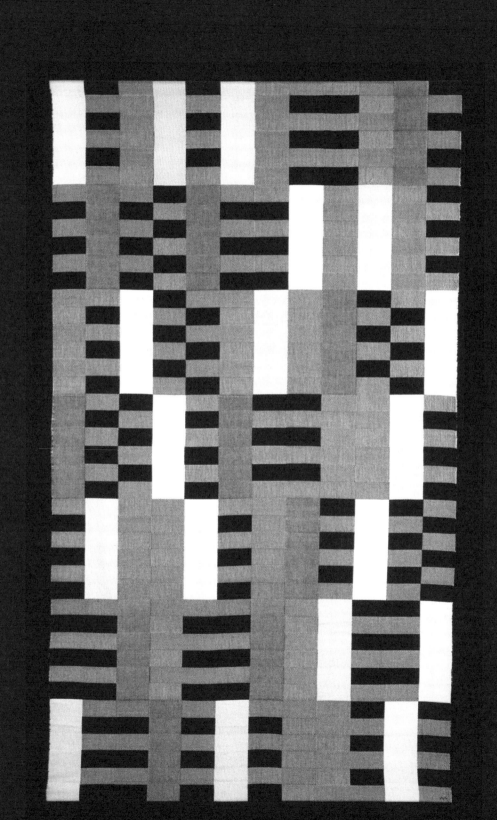

by a woman in a sexist culture, and without institutional authorisation as an artwork ... it carries overtones of amateurism,'[17] a point conceded by Albers herself.

This disparity between the status of 'male' and 'female' work is echoed in contemporary Nepal, where despite weaving being one of the most highly paid opportunities with the best working conditions, young men still travel abroad, risking exploitation or worse, rather than engage with 'women's work'.[18]

To counter the dismissal of weaving as a craft with nothing intellectual to contribute, Stölzl and Albers quietly set about creating a Modernist theory of weaving that set it alongside 'male' pursuits such as painting, photography and architecture. Since then, an escalating movement, led by feminist theorists such as Luise White, Margot Badran and Nancy Hunt, has sought to highlight the 'disappearing women' edited out of the history of design. Women such as Stölzl and Albers, among many others, are

beginning to receive the recognition they deserve. A full-scale retrospective at London's Tate Modern (October 2018 to January 2019) – part of an on-going commitment by the museum to highlight the work of women artists – credits Albers as an 'influential but rarely seen trailblazer' and describes her work as 'a new interdisciplinary art form'.

It is of course important to acknowledge and celebrate the role that women played in design history and continue to play across the world in the industry today, but if differences and therefore inequalities between genders are socially constructed, it is also crucial to challenge the constructs that prevent women from fulfilling their potential. In the words of historian Susan Pedersen, feminist history must:

> on the one hand recover the lives, experiences, and mentalities
> of women from the condescension and obscurity in which they
> have been so unnaturally placed, and on the other to re-examine

17 Adamson, G. (2007) *Thinking through Craft*. London / New York: Berg: 4–5

18 Interview with managing director of NGO acting in Nepal, Label STEP, Reto Aschwanden

⊕ Hanging designed by **Anni Albers** in 1926, woven by **Gunta Stölzl**, Germany, in 1967. Tapestry-woven silk and rayon, linen, 207.6 × 121.4 cm. The original weaving of this hanging was destroyed during the Second World War; it was rewoven by Stölzl and 'AA' is embroidered in the bottom right-hand corner.

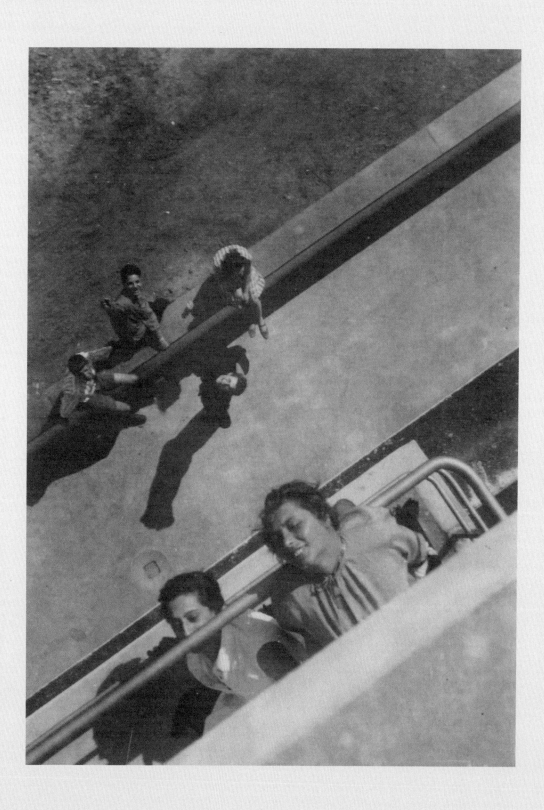

Gunta Stölzl (on the right) and **Anni Albers** on the terrace of the Bauhaus building

and rewrite the entire historical narrative to reveal the construction and workings of gender.[19]

Rewriting the narrative means continuing the work that Stölzl and Albers started, challenging the construction of a hierarchy of materials and processes that places textiles below stone and weaving below architecture. This is important historically but becomes crucial when non-governmental organisations (NGOs) such as Label STEP and Turquoise Mountain argue that raising the status of weaving is the only way to preserve skills in danger of dying out and prevent men making dangerous journeys abroad to seek alternative employment.

This means reinstating craft to claim its rightful place within and alongside art, design and architecture. The fact that the contemporary weavers profiled in this book are overwhelmingly female speaks to the fact that there is still a gender bias in textiles – and this is true across the world. But for those lucky enough to be working autonomously in wealthy countries, their work is no longer restricted by the gender boundaries of the past. Free to choose their medium, they have all actively chosen to work with fibres. They might all combine warp and weft, but the diversity of their work is testament to the breadth of contemporary weaving – a process that holds space for whatever they want it to be, and provides hope for the future for less privileged women the world over.

19 Pedersen, S. (2000) 'The Future of Feminist History' in *Perspectives on History*: 38:7

ALEXANDRA
KEHAYOGLOU

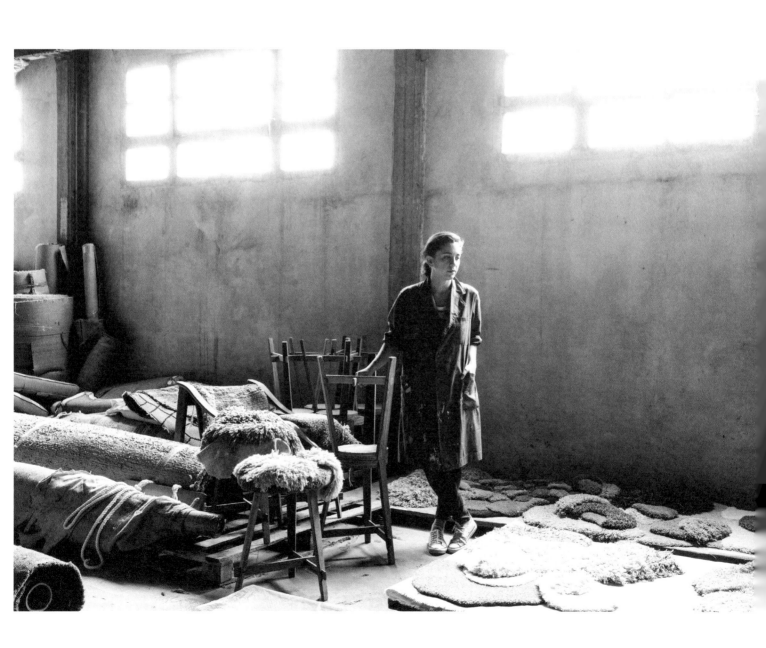

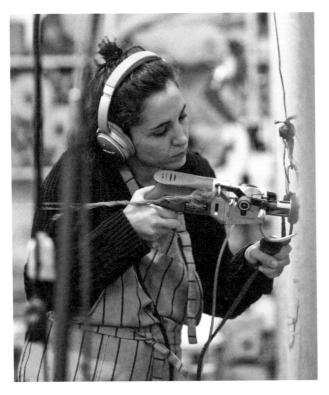

Alexandra Kehayoglou (Buenos Aires, Argentina, 1981) is the only maker in this book who is not technically a weaver. She comes from a family *The New York Times* calls 'Argentina's first family of rug makers' – originally from Greece, her grandparents made carpets in Isparta, Turkey, until war broke out in the 1920s, forcing them to escape to Argentina, taking their loom with them. Kehayoglou works in hand-tufting, a technique closely related to weaving in which carpet-grade wool is applied to a backing fabric stretched across a frame. 'I am an artist,' she says. 'I make carpets that resemble nature, documenting landscapes and territories that are disappearing or endangered. I want to bring attention to forgotten land, to bring remembrance, to act as a bridge between the land and people who seem to have forgotten it.' She started by making use of the waste wool from her family's business and getting to grips with the hand-tuft pistol they now use to make their carpets. 'My father encouraged me

to do something with their surplus material,' she says. 'I started thinking about how I could use this medium to speak about my own work and my concerns with dreams, *refugios*, lost landscapes, and memory.'

Kehayoglou had completed a fine art degree at the Universidad Nacional de las Artes in Buenos Aires and knew that she wanted to make art that talked about space, but found painting and photography too limiting. 'When I discovered the third dimension that carpets can create I knew this was something unique and powerful to continue exploring,' she explains. 'In working with wool, I discovered an ancestral knowledge of the material – something difficult to explain, a deep connection and understanding. I taught myself to hand-tuft and started making *pastizales* [grasslands] resembling the native landscape of Buenos Aires – carpets that depicted disappearing land. The crossover between my family background and my interest in nature felt very deep and I knew this was something I had to work on. Intention is everything, the energy that flows within the fibres has to be right – I am reproducing land that needs to be loved.'

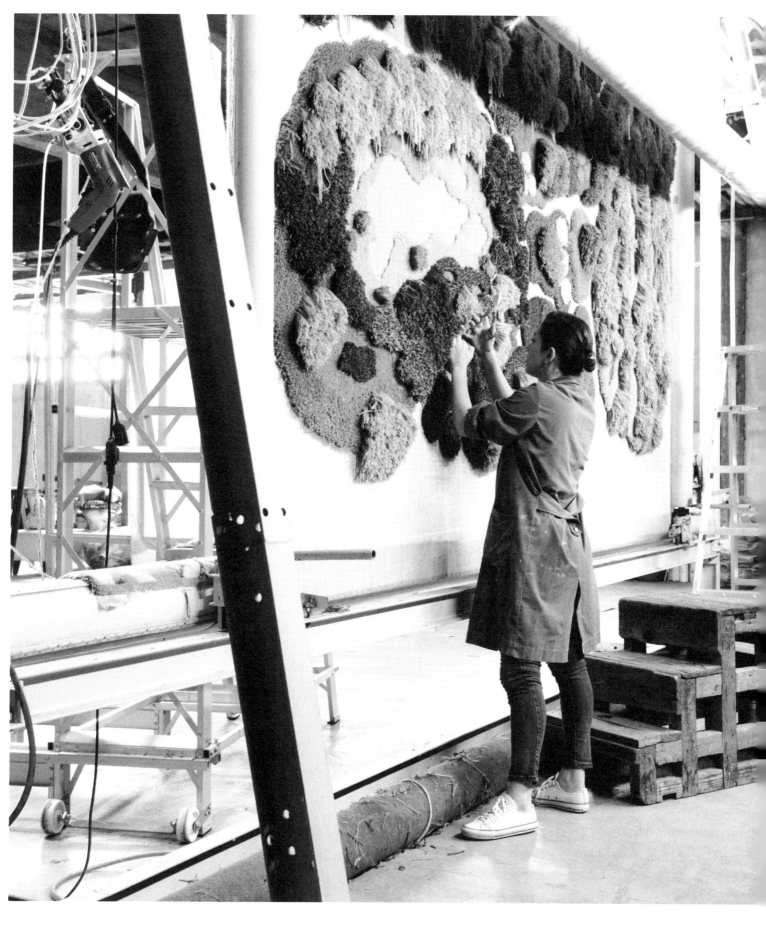

I am an artist. I make carpets that resemble nature, documenting landscapes and territories that are disappearing or endangered and that I'd like to preserve for all time.

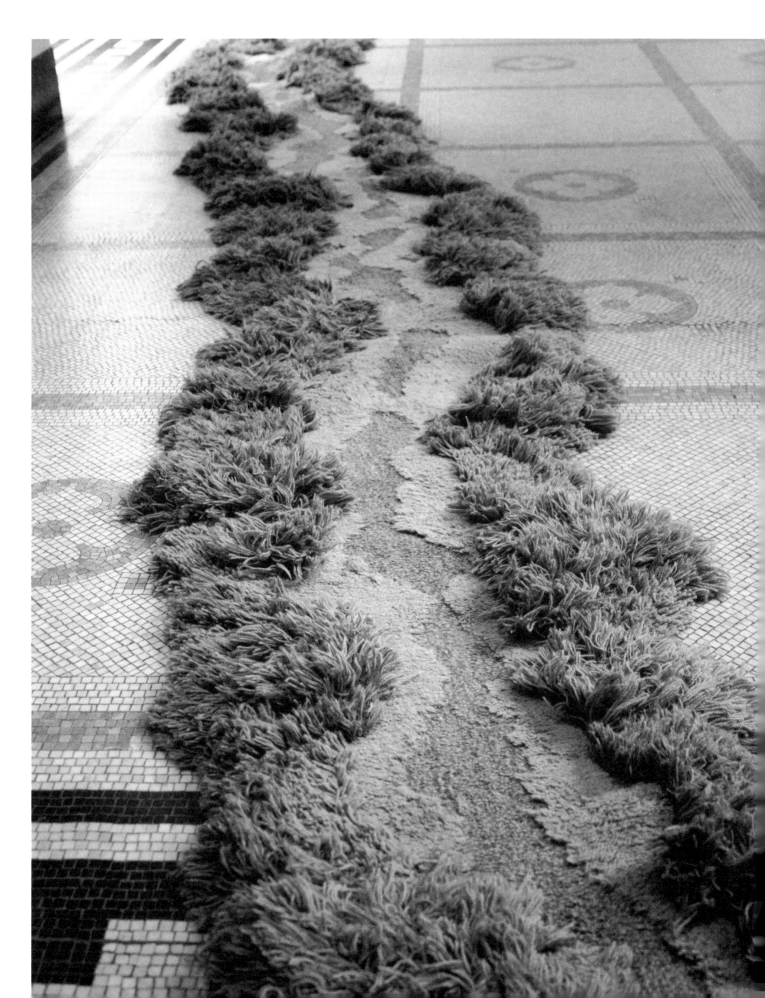

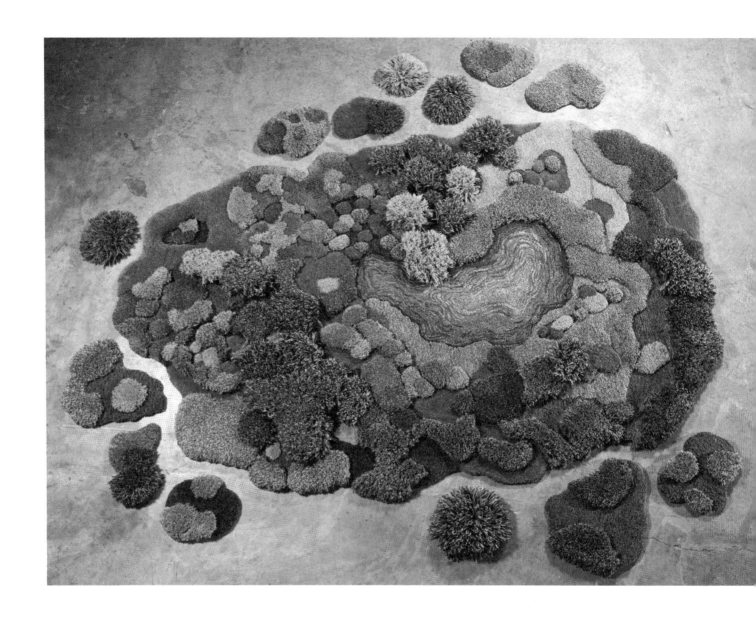

I always start with a field trip – a very intense study of the place.
I document the landscape and drone footage is very useful to help
me understand the different approaches we humans have taken
to the land. I like the perspective it gives me, like climbing up
a mountain and looking at the landscape from there.

ALEXANDRA KEHAYOGLOU

My favourite part of the process is surprise, that instant of losing control over the outcome – things often turn out better than expected. That is as true working from the reverse of carpets and not being able to see what is being revealed on the other side as it is of working with assistants who add their own personal touches. It is like being part of an orchestra: the conductor directs, but the musicians perform. I like that feeling – it opens possibilities.

ALEXANDRA KEHAYOGLOU

DANIEL HARRIS

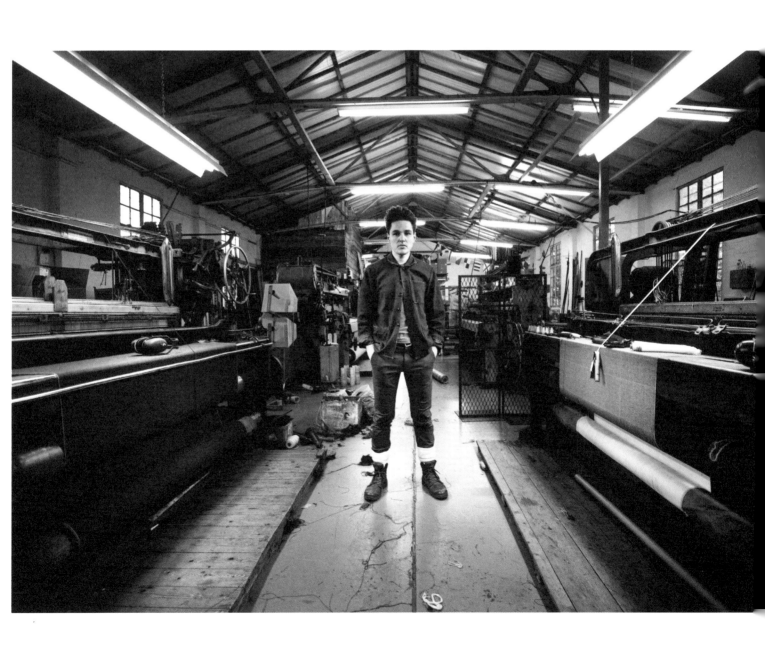

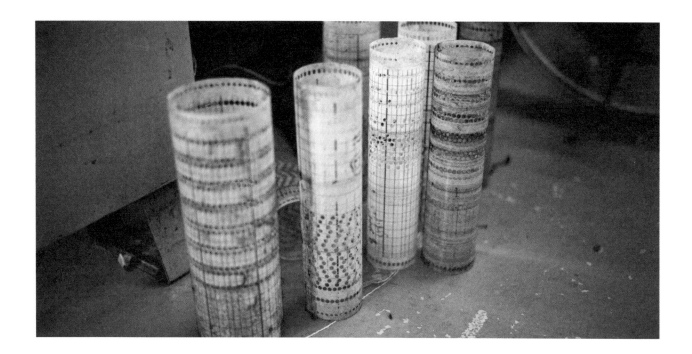

Daniel Harris (Malvern, United Kingdom, 1982) has spent six years salvaging and restoring historic looms that date from 1870 to 1986. The culmination of his endeavours is the London Cloth Company, part of a growing trend for British micro-mills. 'It is one of the few places in the world where you can see the entire history of mechanised weaving from the Industrial Revolution to the digital all in one place,' he says. Far from being a museum, the mill produces commercial woollen and cotton fabrics for high-end clients such as Ally Capelino, Cos and Manolo Blahnik. Despite the calibre of his clientele, Harris describes his work with characteristic modesty: 'Nothing I am doing is ground breaking, there are just certain things that have turned out well.'

Trained as a sewing machinist, Harris started his career as a stitching and pattern technician in the fashion, film and television industries, setting himself exacting standards of perfection. 'It would not be unusual for me to almost finish a garment only to throw it away and start again,' he says. It's no wonder his thoughts turned to the fabric itself, and a desire to oversee the whole process soon led to weaving. 'I do have an obsessive personality', he confesses, 'so once I started weaving, I really threw myself into it.'

Ruling out hand-weaving as 'too difficult, too slow and far too complicated', Harris set about finding a power loom. Modern looms were out of budget so 'redundant junk that needed serious restoration' was his only option. 'I honestly thought, "How hard can it be?"' he laughs. 'I cannot overstate how little I thought about this before I started.' In the early days of the company, Harris devoted most of his time to simply getting his machines up and running, often buying two looms for the parts to make one. Today, he runs a 2600 square-foot mill with five looms, making fabric full-time. He often sleeps in the mill overnight during projects for which he uses the older looms. 'Weavers don't retire, they die,' he says. 'That is something that I was told very early on by an elderly weaver, which sums up the all-encompassing effect weaving has on your life – so I was warned.'

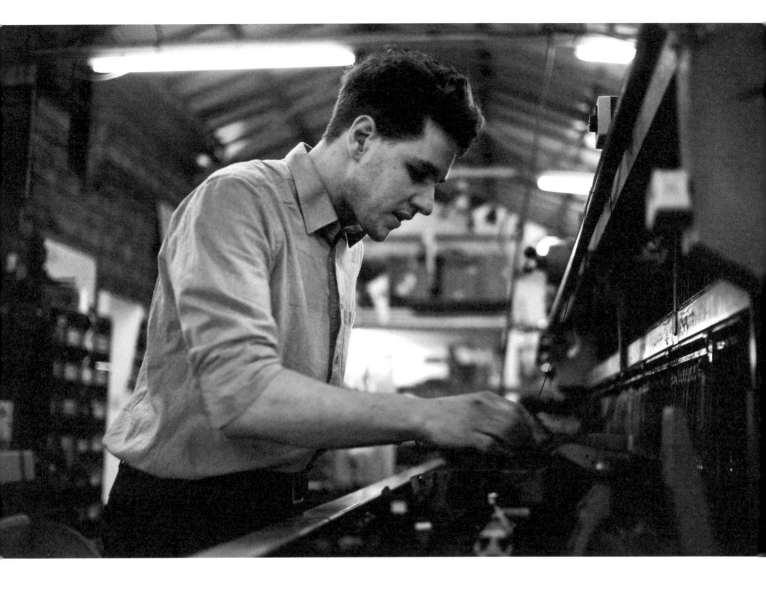

I knew that I did not want to do hand-weaving as I have absolutely no patience and it all looks way too difficult, slow and far too complicated. So I knew that I would need an industrial loom of some sort, quickly realising that very modern equipment was out of the question so old redundant junk was the only option. The only problem is that anything that old will need to be restored. And I honestly thought: how hard can it really be?

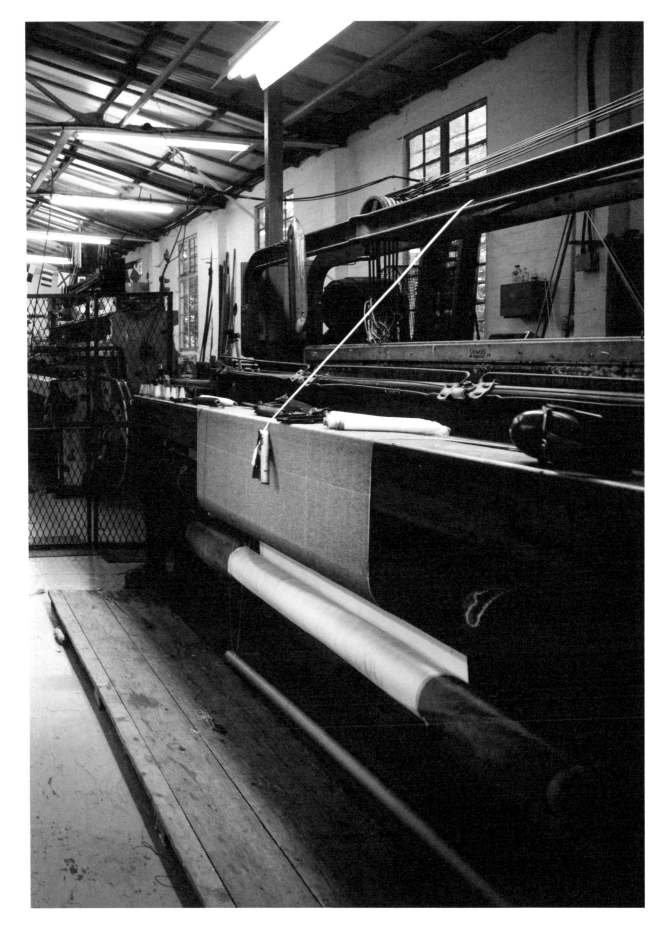

73 D A N I E L H A R R I S

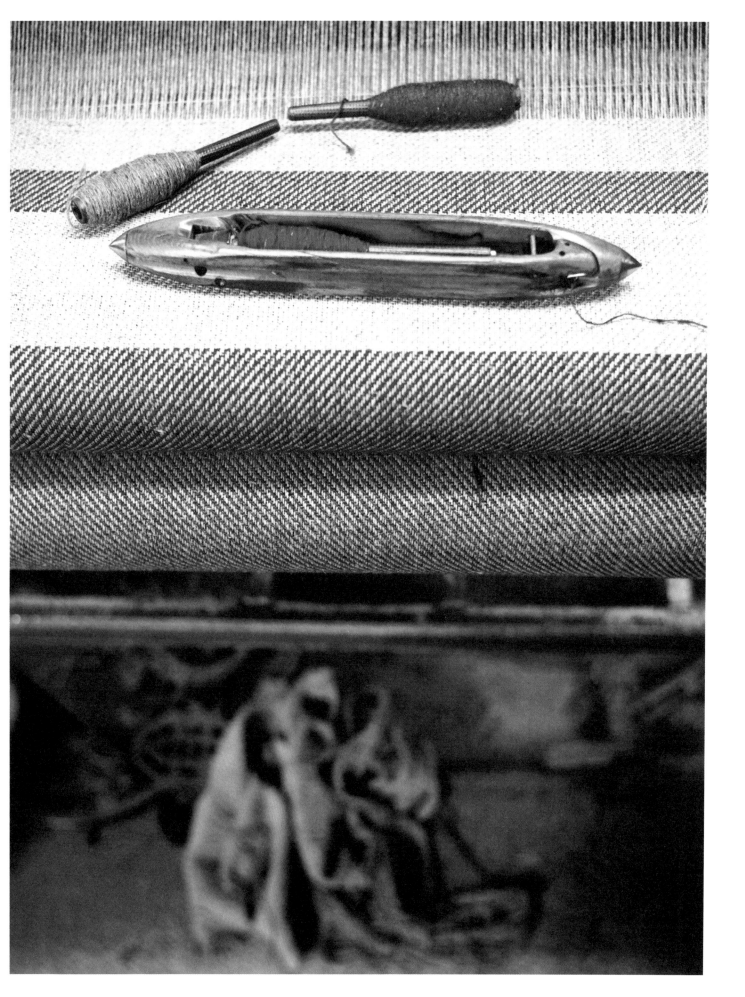

Weaving can be a bit of a lone war against the machines, not dissimilar to the Terminator films. It is something best done alone and quarantined from the world. The process takes so much concentration and can so easily go horribly wrong if you're distracted.

We have looms dating from as early as 1870 and 1986; it is one of the few places in the UK or even the world where you can see the entire history of mechanised weaving from the Industrial Revolution to the digital era all in one place, working and being used commercially.

KARIN CARLANDER

Karin Carlander (Kerteminde, Denmark, 1959) holds a Masters of Linen certification, awarded to spinners, weavers and knitters who have committed to 100% European traceability from the sown seed to the final fabric. This means she weaves using yarn spun from naturally grown flax that has been soaked within a specific run of fields that stretch from Caen in France through Belgium to Amsterdam in the Netherlands, where the water requirement is met entirely by rainfall. Cotton requires approximately 7,100 litres of water for every kilogram harvested. 'A comparative analysis of the life cycle of a linen shirt and a cotton shirt shows that the environmental impact of a cotton shirt is up to seven times that of a linen shirt,' says Carlander. 'Linen is the only vegetal fibre used in the textile industry that is native to Europe and it is the oldest known textile developed by man,' she explains – and we now know that linen dates at least as far back as 36000 BC as tiny fibres were found in a cave in the Georgian part of the Caucasus in 2009. 'The intensive ways of growing fibres for our clothes are not necessary. If we were better informed about the materials we use every day, we would be able to make better choices when we buy our clothes. But for me, it is also important that my textiles have roots in nature and in the culture I come from.' Using linen, Carlander weaves functional objects (the first product for her design brand was a simple tea-towel) that reinterpret traditional Nordic crafts for everyday use – another way in which her work

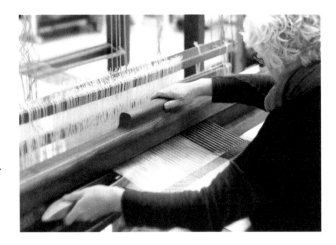

has its roots in her culture. 'I work with functional textiles, because I believe the objects we handle in connection with everyday chores and activities should hold artistic value,' she says.

There is an appealing sense of achievement in constructing and creating an object from scratch. Anyone who masters a craft holds tacit knowledge that is conveyed through their hands and by example. Many of the old crafts are disappearing today, and that makes us poorer. Craft-based objects are created at a pace that leaves room for reflection, and that gives us a deeper understanding of and respect for how the objects we live with are made.

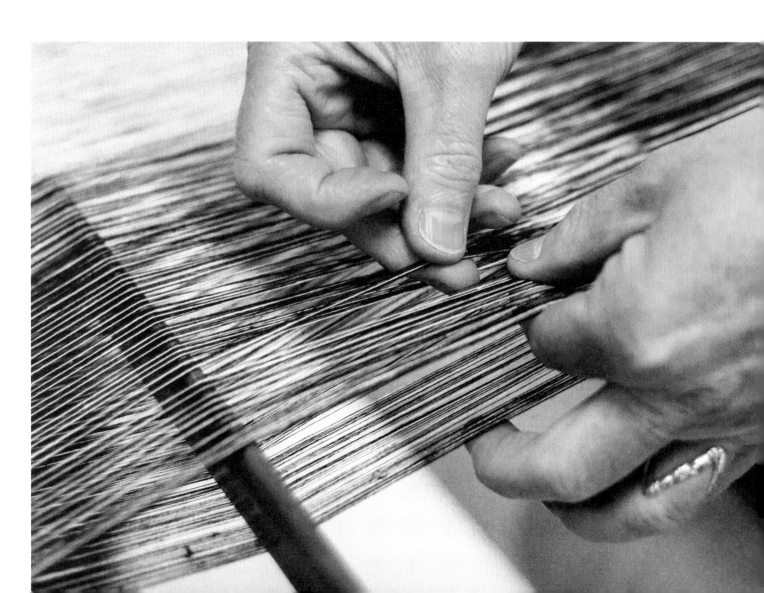

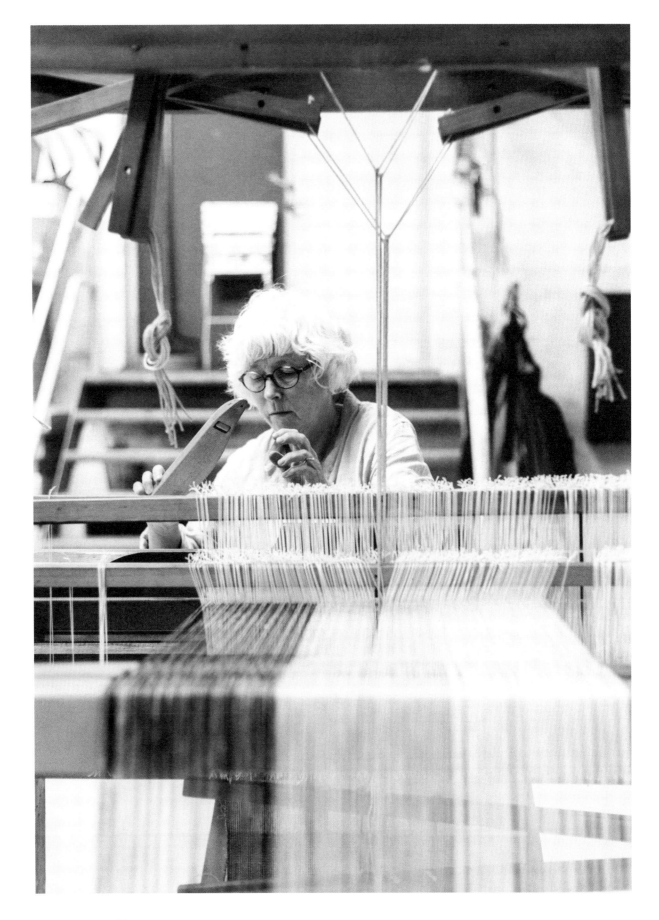

KARIN CARLANDER

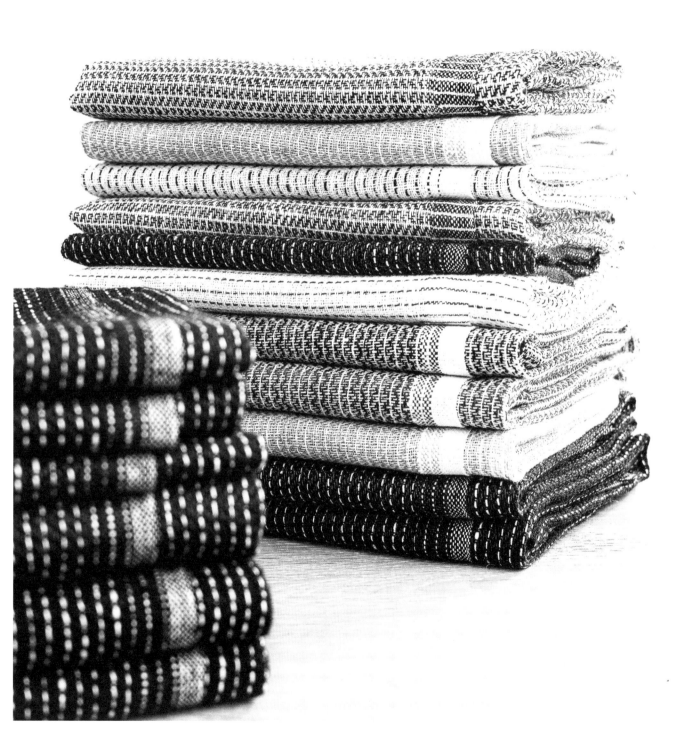

I have worked with linen for many years, and it remains my favourite material. Linen is a challenging material that is never fully tamed, and it has a mind of its own. It pushes back when I work at my loom. At the same time it gives my work a certain personality, reflecting the light when I try to capture the immaterial moment in yarn and colour.

ERIN M. RILEY

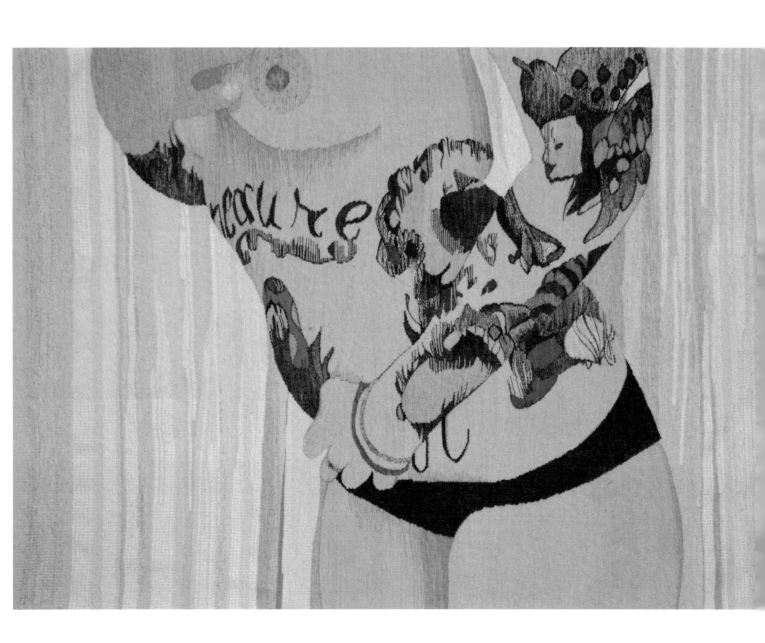

When asked to describe their work, Erin M. Riley (Massachusetts, United States, 1985), who identifies as gender non-binary, simply says, 'wool, cotton', and when asked about its purpose, 'survival – my own'. Both statements hugely underplay the intensity of this Brooklyn-based artist's work, which combines the traditional skill of tapestry weaving with arresting images depicting sex, masturbation, menstruation, pornography, death, drugs and mental illness.

Riley initially sourced a great deal of imagery – usually of women – through the internet: 'I used the internet as my lifeline as an antisocial young teen. Today it inspires, informs and critiques my work.' There is a paradox in the juxtaposition between these instantly available internet images and the six hundred hours or more it can take to weave the resulting tapestry. Having realised they were using the images in lieu of their own body, Riley started to use self-portraits instead. 'I live my life and inspiration comes in waves,' they say. 'Reading the news, watching television, dating, reading ...' One recent tapestry depicts screen shots taken at the point of orgasm during masturbation; another shows a bloodstained tampon.

A choice of three floor looms – a 24" Dorset loom, a 48" Macomber and a 100" Clement on which Riley can make tapestries up to 8 by 8 feet – ensures the images are given the space they deserve, inspired by large-scale subversive work made by women in the 1960s on looms that are no longer in production.

It is not only the content that matters – working sustainably is important too: 'I source my materials from manufacturing excess. I avoid buying new because there is so much waste in the textiles industry.' Riley dyes weft wool with acid dye and bleach, combining it with a cotton or polyester 8/4 rug warp. It's a process that brings huge satisfaction. 'I enjoy every part of the process,' says Riley. 'It all satiates me in different ways: meticulous work when I'm focused, active work when I am energetic, there is a process for every mood. I am grateful people like to look at, show and support my work, but I make it for myself.'

I make my work for myself. I am grateful people like to look at the work, show it and support it. I would not have anything to do with my time if I had someone make my work for me. I have the privilege of time, and I use that time to make my work.

The internet is vital, I used it as my lifeline as an antisocial young teen. Today it inspires, informs and critiques my work.

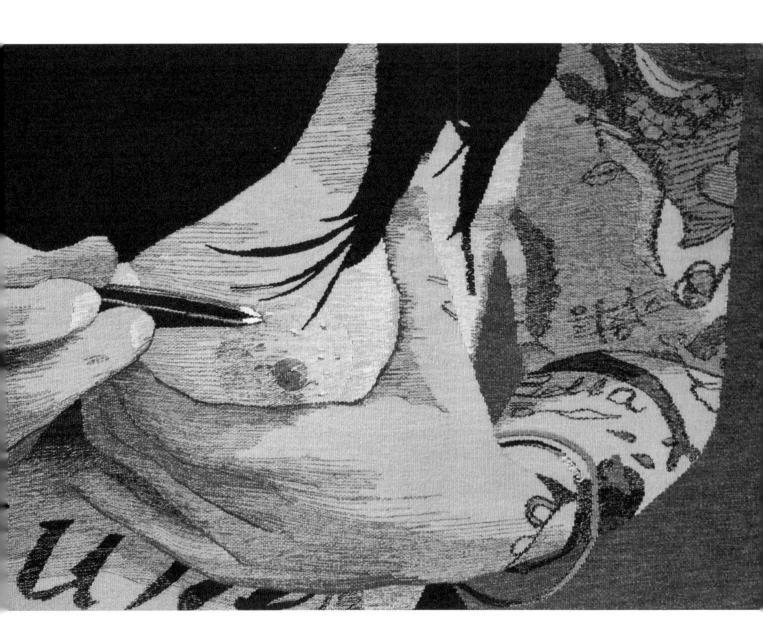

ERIN M. RILEY

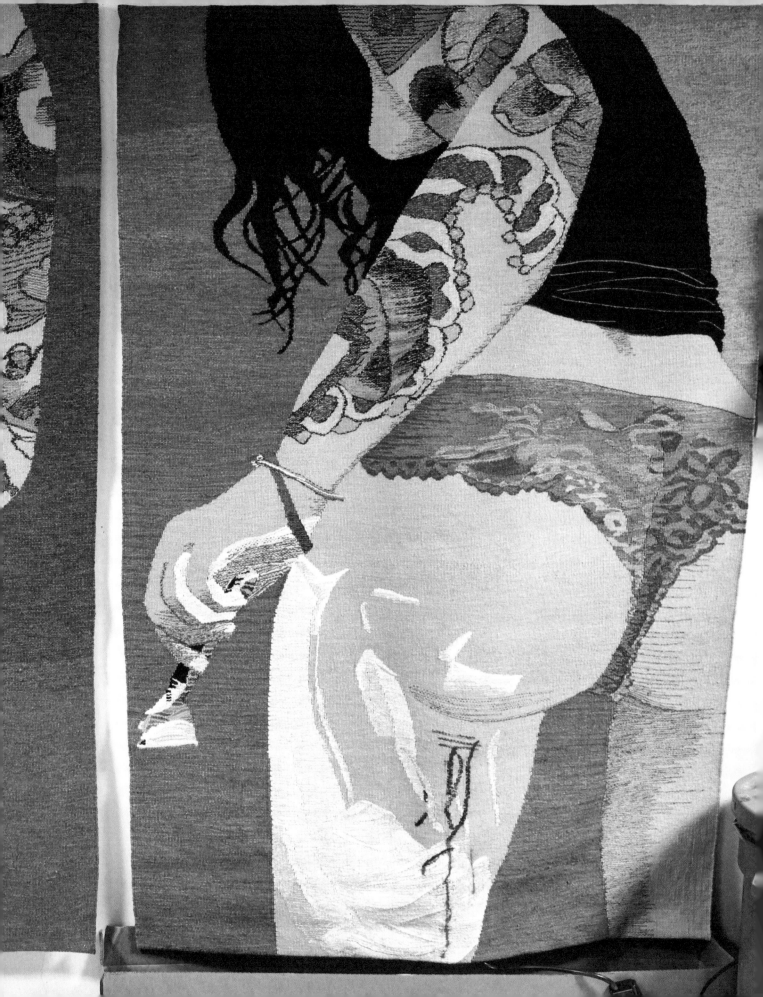

My work is a culmination of ideas, inspiration and labour. As soon as I have a rush of ideas working towards a show or a new body of work, I start sketching and prepare for hours – dyeing yarn, warping the looms – and then I start weaving. The queue of things to weave is fluid and depends on how excited or challenged by certain pieces I am.

ERIN M. RILEY

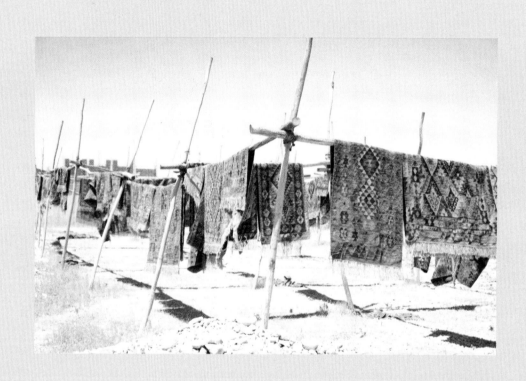

WEAVING MIGRATION

'He who is false to the present duty breaks a thread in the loom,
and you will see the effect when the weaving of a lifetime is unravelled.'[1]
— WILLIAM ELLERY CHANNING

Weaving has its roots in migration. Across the 'rug belt' from Morocco,
through North Africa and the Middle East, into Central Asia and northern
India, there is a long tradition of nomadic women spinning the by-products
of their tribes' animal husbandry into yarn. These itinerant craftswomen
wove everything they needed, from floor coverings to containers that were
light enough to travel with them as they moved from one home to the next.
In fact, so entwined are weaving and migration that the word 'refugee'
came into the English language with a community of weavers, artisans and
professionals. In 1685, after King Louis XIV revoked the Edict of Nantes and
with it Protestants' freedom to worship, 200,000 Huguenots left France,
fleeing religious persecution. Between 1670 and 1710, a quarter of them came
across the Channel, seeking refuge in England, and so the French word *réfugié*
became 'refugee.' Those whose livelihoods were tied to property or land
were forced to stay, but because their skills were in their hands, and their
trade was in demand, the weavers could escape. Historians estimate that
half the Huguenots arriving in England moved to London – many settling in
Spitalfields, where food and housing were affordable, and where the existing
silk trade was unencumbered by the restrictions of the guilds inside the City

1 Quoted in Goggin, M. and Tobin, B. (2016) *Material Women, 1750–1950*.
 Abingdon: Routledge: 276

⊙ Kilims drying in the outdoors after their washing process at Afghan Bazar's work space
in Mazar-e-Sharif, Afghanistan

walls. The skills and work ethic of the Huguenots gave the English silk trade a huge boost and soon earned the area the nickname 'weaver town'.

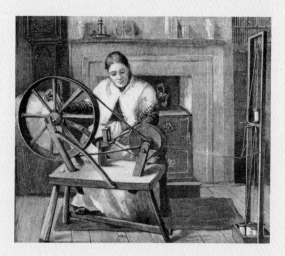

Three centuries after the Huguenots brought silk weaving to England, following the 1959 Tibetan uprising and exile of the Dalai Lama, more than 20,000 Tibetans migrated to Nepal, fleeing Chinese repression and bringing their weaving skills with them. Nepal, now famous for its hand-knotted carpets, has little weaving tradition of its own, but a Swiss-led aid project[2] in refugee camps built on the skills of the Tibetan people and the Nepalese carpet industry – now responsible for the country's largest export – was born. Although the majority of modern-day weavers are Nepali (Tibetans still own many of the companies) and the style of rugs is contemporary, the weaving techniques remain the same: employing the traditional Tibetan knot.

2 In 1959, the first comprehensive cooperation agreement between Nepal and the Swiss Association for Technical Assistance was signed, following a request in 1950 by what was then His Majesty's Government of Nepal, in response to which a group of four Swiss experts (the Swiss Forward Team) arrived in Kathmandu to advise on Nepal's development. The initial phase of the Nepal–Swiss partnership was led by pioneers from Nepal and Switzerland and focused on the production of cheese and carpets.

⊕ Spitalfields silk worker winding silk in her cottage, London, England, late 19th century. This enclave of the silk industry was founded by Huguenot refugees from France after Louis XIV's Revocation of the Edict of Nantes (1685).

We often view historical migrants with respect and admiration, yet much of contemporary Western media paints a less favourable picture of today's refugees. In less than two decades, the 21st century has already seen mass migration as people flee wars in Syria, Iraq, Afghanistan, Somalia and Darfur; military conscription and forced labour in Eritrea; and untold atrocities in other countries around the world. Populations are displaced within their own countries by war, famine and religious persecution; and second- and third-generation migrants are forced back to 'home' countries they have never seen, rejoining broken economies unable to support them. The United Nations High Commission for Refugees (UNHCR) recognises that, among the 16.1 million refugees it supports across 128 countries, there is a diverse range of often unique and endangered skills that travel even with people who are left with little else. In the same way that Huguenot silk weavers and Tibetan carpet weavers were able to use those portable skills to build new lives, so today's refugee communities are using weaving as a way to survive, and in some cases thrive, within their new circumstances and surroundings.

93

For women internally displaced within Afghanistan, there is very little work that is culturally acceptable – in some parts of the country it is difficult for them to leave the house, let alone the village. Weaving, traditionally seen as 'women's work' and carried out within the privacy of the home, is a rare exception that charities, NGOs and social enterprises are tapping into to empower women to generate their own incomes. One such organisation, Arzu Studio Hope, was founded by Connie Duckworth after she witnessed women and children living in the wreckage of bomb-damaged buildings in Kabul. She started working with just 30 women, weaving hand-knotted pile rugs from sheep's wool. Today the organisation backs shepherds, spinners, dyers, weavers, finishers and transporters, providing employment for a thousand women, who in turn support four thousand family members across rural Afghanistan – 20% have at least one child not only in education, but in university, helping to break the cycle of poverty.[3]

Weaving is not only a route to financial independence for migrants arriving in new territory, it can also support those returning to their native countries. The war in Afghanistan displaced a population of 1.3 million people into neighbouring Pakistan from the 1970s onwards. Despite UNHCR protection,

3 Available online: www.arzustudiohope.org/empower-women-page

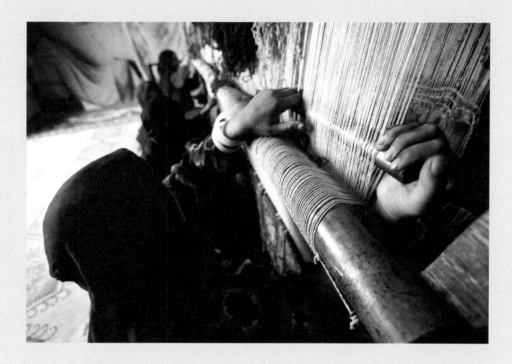

human rights organisations claim abuses, threats and coercion at the hands of the Pakistani government have forced 600,000 Afghans back to Afghanistan since July 2016. 'After decades of hosting Afghan refugees, Pakistan unleashed one of the world's largest recent anti-refugee crackdowns to coerce their mass return,' said Gerry Simpson, senior refugee researcher at Human Rights Watch.[4] Most did not have homes to return to and were unable to return to areas still affected by war and deprivation – younger generations were returning to a country they had never seen. Some of those returning to the Balkh province are finding ways to build new lives and integrate into local communities by weaving traditional kilim cushions, using hand-spun wool from local sheep and coloured with natural dyes, all while developing leadership and business-management skills, in a project supported by non-profit group Turquoise Mountain. 'Working with Turquoise Mountain has meant significant changes in my life,' says weaver Khair-ul-Nesa.

4 *Pakistan: Mass Forced Returns of Afghan Refugees.* Available online: www.hrw.org/news/2017/02/13/ pakistan-mass-forced-returns-afghan-refugees; accessed 09 April 2018.

⊕ Female weavers adjusting their loom whilst working on a couple of carpets from their home

I have learned about my rights – I have the right to go out and
visit the bazaar or another weaver. Previously my husband did
not permit me to leave our home. Sitting at home weaving is
not a punishment for being a woman. Since I participated in
the training programmes, I have found ways to solve my life
problems and I even celebrated Women's Day for the first time.
I have also spoken with the exporter and bargained to increase
my wage.

Turquoise Mountain works with five thousand craftsmen and women
across Afghanistan, Myanmar and the Middle East to revive traditional crafts
– creating jobs, skills and a renewed sense of identity.[5] 'It is very important
to protect our traditional carpet weaving. Our culture and history is hidden
behind these traditional designs – we have done the same for the past five
thousand years and we try to pass weaving from generation to generation,'
says Shah Bebe, another Turquoise Mountain weaver. 'Carpet weaving is part
of our culture and we protect this beautiful skill and art,' adds Khair-ul-Nesa.
'I learned it from my mother and now I am teaching my daughter.'

While Turquoise Mountain supports refugees, fair-trade NGO Label STEP
is attempting to reduce the economic migration out of Nepal. Around 10% of
the Nepalese population works abroad and the money sent home has become
so important to the country's economy that some argue it is cheap labour,
not rugs, that now comprises Nepal's biggest export. Five hundred thousand
people (95% of them men) have left the country as labour migrants, most to
Malaysia, Qatar and Saudi Arabia. It is estimated that 1,200 workers (many
of them Nepali) have died building stadia in Qatar for the 2022 World Cup.
Coffins still arrive at Kathmandu airport every day – if the pattern continues,
1 in 500 workers won't return home alive.[6] Hari Chandra Ghalan is one of
the lucky ones – having returned from construction work in Qatar, he has
been working in a Label STEP carpet factory for two years. 'There are huge
differences between working in Qatar and working here,' he says. 'This is our
birthland. I feel that to work in a foreign country is like being sold.' Even for
those who prosper abroad, the extent of the migration and its young, male
skew is damaging families, social structures and communities – the impact

5 Available online: www.turquoisemountain.org

6 Available online: www.label-step.org

of which is neither measured nor discussed in Nepal. 'We hope that our campaign encourages Nepalese workers to look for work and happiness in their homeland instead of accepting often precarious and dangerous jobs overseas,'[7] says Label STEP's managing director, Reto Aschwanden. Weaving jobs in Nepal enable families to stay together and offer better pay and working conditions than the alternatives, both locally and overseas. 'I prefer this work as it is indoors and the working hours are flexible,' says Label STEP weaver Kanchi Maya. A large part of Label STEP's work is about raising awareness and changing perceptions among Nepal's would-be migrant population. 'Weaving has been my passion since I was very young,' says Sunita Rai, another weaver in a factory supported by Label STEP. 'It's a traditional craft and I would love to continue as long as I can. I tell my son that weaving is special and should be respected. It is because of this work that he is able to complete his secondary education.'

A growing number of international enterprises are waking up to the extensive skill base within today's refugee populations. In 2017, UNHCR established online retail platform MADE51 to connect the multitude of charities, NGOs and social enterprises working with such artisans to consumers all over the world. Online shop Ishkar, set up by Flore de Taisne and Edmund le Brun, is also connecting makers with buyers. The long-term impact of war, together with cheaper and more fashionable imports from China, has destroyed local demand, so online platforms can enable weavers to reach a previously inaccessible international audience. Ishkar's products include camel-hair and gold-thread shawls, hand-woven by women internally displaced within Syria, that retail for over $350, as well as rugs designed by the likes of Frank Gehry and Zaha Hadid and made by Arzu Studio Hope weavers in Afghanistan – demonstrating the value and viability of the markets they are creating.

If an aid project in a refugee camp in Nepal can evolve into the country's largest export within a generation, providing employment not just for Tibetan immigrants but for Nepalese nationals, and camel-hair shawls made by Syrian refugees can earn over $350 a piece, perhaps it is time for the West to rethink its attitude to the immigration crisis – seeing refugees less as problems to be solved or passed on, and more as humans with unique skillsets

7 Available online: www.label-step.org

and something valuable to contribute. 'Weaving is global, primal, and elastic enough to hold everyone and their traditions,' says first-generation Chinese-American weaver Lauren Chang (see following pages).

> If we admire a textile, perhaps we should respect the people, traditions, cultures and skills that produced it, because weaving is nothing if not a reflection of people and communities. As migration, relocation, assimilation, adaptation have always been part of the human story, so too has weaving. Whether the end result is art, utility or something in between, we make for other humans, so humanity seems a good place to start.

A more compassionate and humanitarian approach might preserve not only lives and livelihoods but also the craft skills that have shaped the besieged cultures of refugee populations – skills that, without international recognition and support, might be lost forever.

LAUREN CHANG

Lauren Chang (California, United States, 1972) was nowhere near a loom when she first fully understood the breadth of weaving: 'I spent weeks peering through a hand-held microscope examining woven samples only a few centimetres squared.' She was taking a technical class at Musée de Tissus in Lyons, France, after having hands-on experience of weaving and an MA in textile conservation. She analysed each sample, identifying the materials and the twist or spin and ply of the yarns, counting the warps and wefts, and determining the weave structure. 'Looking at textiles with this level of detail and rigour increased my intellectual understanding of the medium,' she says. 'But more importantly, it embedded a deep appreciation of the skill required to create extraordinary textiles.'

It was a decade before she started weaving regularly herself. 'My first commission was made entirely of yarns I had spun and then dyed with madder,' she says. 'I remember cutting it off the loom and wrapping it around my shoulders to ensure it was the right length. I was unprepared both for how the cloth transforms when wrapped around the body and for how I felt wearing it. I knew I needed to keep making cloth.'

Today she combines her academic expertise with making. 'First and foremost, I make cloth for people to use,' she says. As textile conservator, it was her role to mitigate the deterioration of textiles, but she saw how worn areas told a story about the community that created and used them. 'Now as a maker, I hope my cloth will be loved, used, worn and cherished. I want it to hold memories and stories and live a life beyond my hands.' And if her products are about people, so too is her practice. 'It is a choice to engage in meaningful conversations; to seek expertise where it may have been overlooked and to listen,' she says. 'Connecting with other makers, farmers and shepherds has given me a greater understanding of the power of generosity and kindness. Coaxing fibre from fleece to fabric, I literally hold a shepherd's year in my hands. This seasonality of work echoes the seasons of life – the cycle of preparation, execution and reflection. I hope my cloth reflects the interdependence and rhythm of life and the kindnesses that have resulted from unique relationships. I treasure the community and life that making cloth by hand has afforded me.'

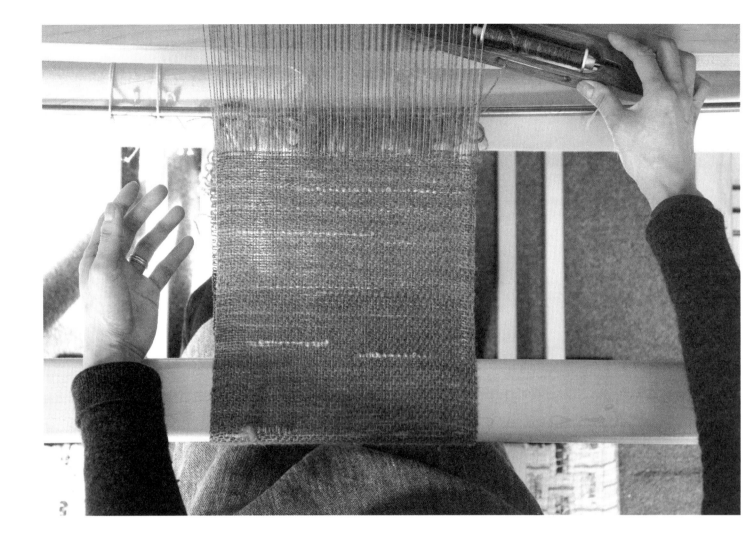

I weave a lot of samples to test colour, pattern and drape. Then I prepare for making the final piece. Scaling up in textile work, whether it is dyeing, blending fibres, spinning or weaving, rarely results in a perfect correlation between sample and final product, but samples provide an excellent reference for current and future projects.

As a conservator I was trained to dye in a very specific and technical way. The dyes needed to be lightfast and washfast so as not to fade or transfer to the artwork. I dyed stitching threads and repair materials to match the colour of a specific historic textile. The recipes had to be repeatable because each dye session was time consuming and laborious. Good records may have meant the difference between dyeing for a day and dyeing for a week. In my own practice, I still enjoy the discipline and chemistry of dyeing, and I like creating my own palettes.

TANYA AGUIÑIGA

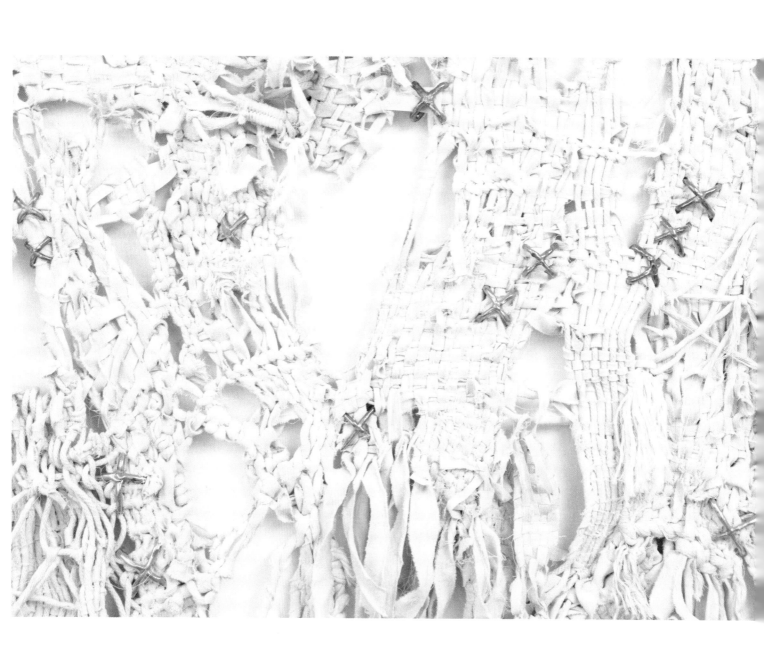

Tanya Aguiñiga (California, United States, 1978) makes furniture, textiles, accessories, site-specific art installations, and community-based craft interventions that explore, expose and solve problems. 'An overwhelming sense of grief and impotence overcomes my soul as I try to understand my cultural history,' she says. 'My sense of self is riddled with dichotomous punctures.'

Having learnt to weave on an 8-harness floor loom at art school, Aguiñiga discovered back-strap weaving with Mayan women in Chiapas, Mexico. 'Learning how to weave in a manner that was pre-colonial and so physically connected to one's body, my practice was completely blown open,' she says. 'I began working towards ways of decolonising my own processes and thinking more about my bodily connection to the process as well as ways of creating without machines or specialised tools, and the power that holds conceptually.' Since that experience she has continued to weave 'off-loom', preferring the freedom more eccentric methods offer. 'I feel stifled by floor looms and their rigidity,' she says. 'I love ability to quickly fix and change what I am making and I am drawn to teaching others how liberating it is to create organically, driven by intuition and structure.'

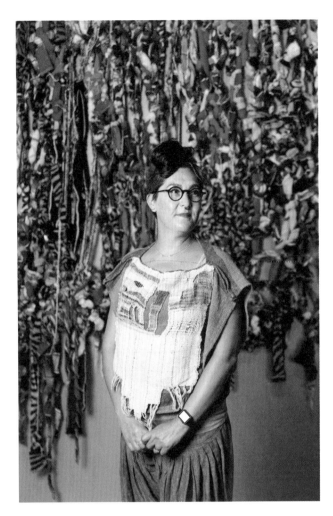

Her connection with others is a big part of what drives her practice – her studio comprises four to 10 women at any one time. 'The studio is multifaceted, so we have women that help with community outreach, educational projects for non-profits, grant writing, and object production,' she says. 'We have been all female and female identifying for years now, with the exception of a few LGBTQ male assistants. My work is an opportunity for me to mentor other women as well as creating a supportive space for people of colour and LGBTQ artists and designers.' There is no typical day, with the studio's current workload including a non-profit project at the US–Mexico border, preparing for lectures, teaching, travel, exhibitions and commissioned pieces. 'My work is craft-centric and uses material history and context to work towards making space for more equitable relationships between people, so it takes many forms,' she explains. 'Working with materials like cotton and wool, I use preconceived notions of class as a starting point for conversations about socioeconomics, gender and culture.'

My yarn is mostly made from deconstructed rope that I source locally. It is typically used for marine applications or for use at the morgue and meat-processing facilities.

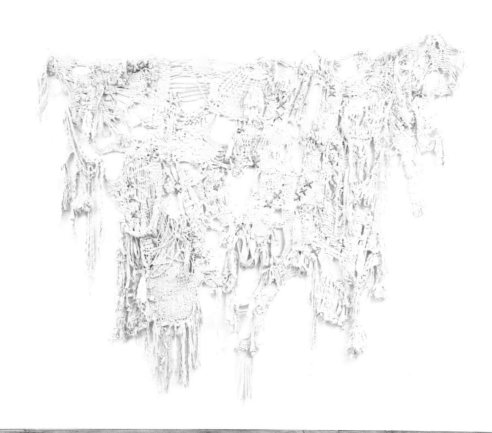

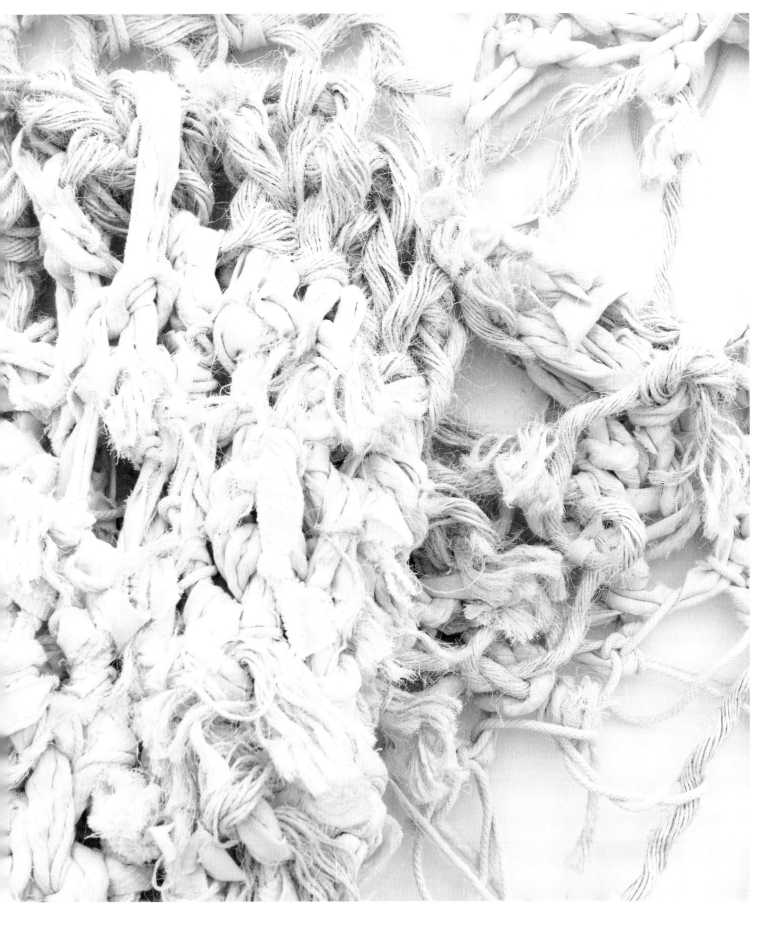

TANYA AGUIÑIGA

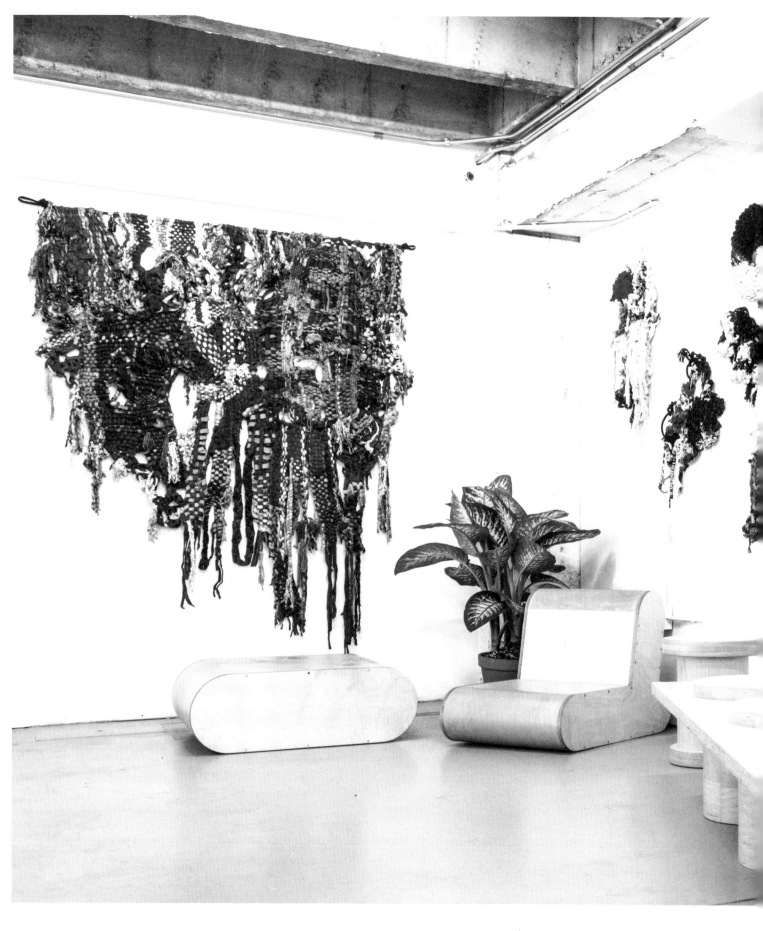

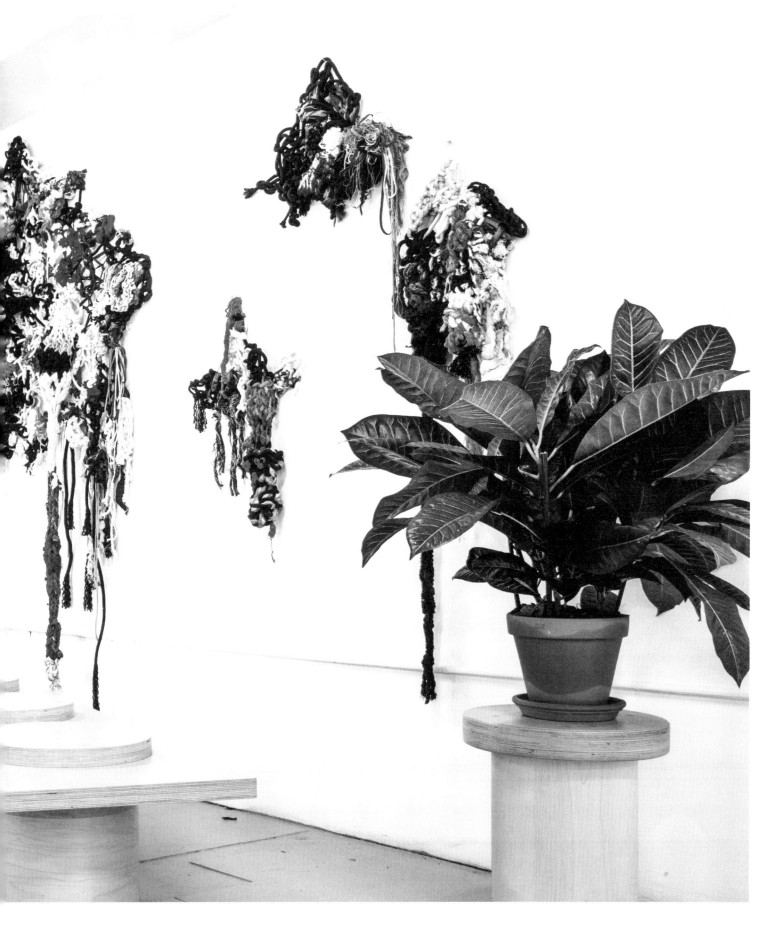

TANYA AGUIÑIGA

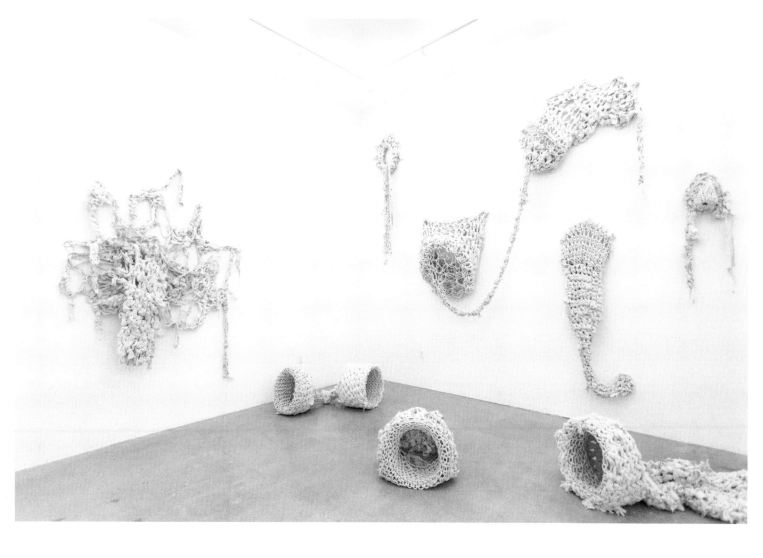

An overwhelming sense of grief and impotence overcomes my soul as I grasp to understand my cultural history. Years of power and oppression, dignity and insignificance. I often attempt to solve problems or bring attention to them through my work in the hope of making the solutions part of the conversation we are having as a society.

TANYA AGUIÑIGA

RACHEL SCOTT

Rachel Scott (Fulmer Chase, United Kingdom, 1940) wove her first tapestry rug in 1976 to replace a worn-out stair carpet. 'I had been making braided rag rugs, but a friend said, "Welsh wool is the thing." She knew a cottage in Wales where builders had been going up and down the stairs in their hobnail boots for 20 years and the carpet still looked as good as new,' explains Scott. She took a spinning and tapestry-weaving course at the Handweavers Studio in Walthamstow, bought some Black Welsh and Jacob fleeces from a farm local to her brother – who made her a bobbin – and set about weaving on a modified bed base. Her then husband stepped in and made her a frame loom from some wood he found in a skip, which turned out to be just the right width for stair carpets. Both the loom and the rug were a success and are in use to this day.

Having trained in painting at London's Royal College of Art from 1959 until 1964, taught pottery at the Ursuline Convent School in Wimbledon, and knitted clothes for herself ('I have stopped making clothes now – I have enough to see me out'), today Scott is a weaver, making tapestry rugs on that same frame loom with her own hand-spun undyed wool from coloured breeds of British sheep. 'Sheep were the wealth of Britain in medieval times,' she says 'Their wool was so valuable that in East Anglia there are nearly

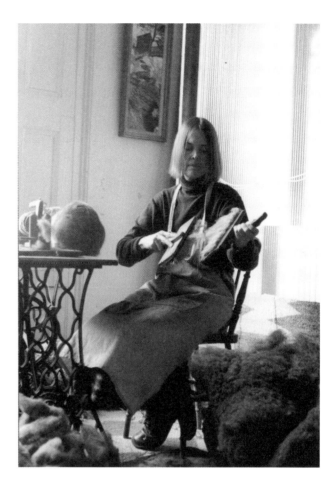

six hundred churches built from its proceeds. It is sad that wool is now so unimportant that Herdwick fleeces are burnt because there is no market for them. I'm glad that, in a very small way, I can make use of them.'

Scott works in a small room at the top of her house, washing her rugs in the bath, drying them over two broomsticks balanced on a chair, and storing them in a pile, currently 70 rugs high, on the spare bed. Each day runs to a typical schedule – she weaves from 9am until 1pm listening to BBC Radio 4, accompanies her husband to his art studio in the afternoon, and then spins in the evenings. 'Making things by hand is the only way for me and has been since I was a child,' she says. 'Besides, what else would I do with my time?'

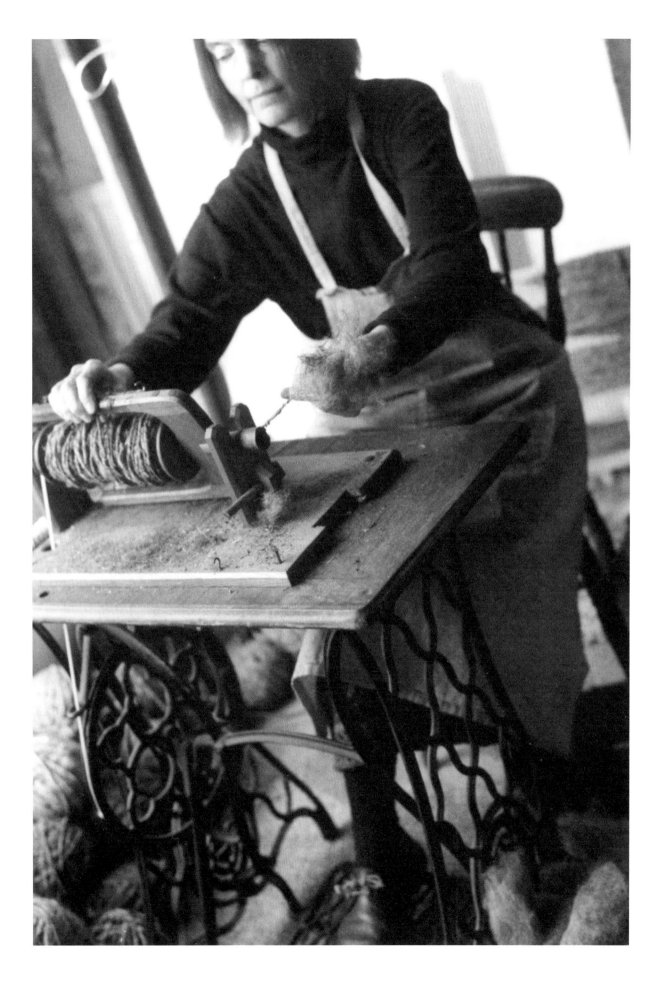

When I began weaving I seemed to spin the wool more finely and the pieces were more complicated, with curves, more like paintings. But gradually they have evolved into starker, more geometric shapes and are true to the nature of weaving, with its horizontal and diagonal straight lines.

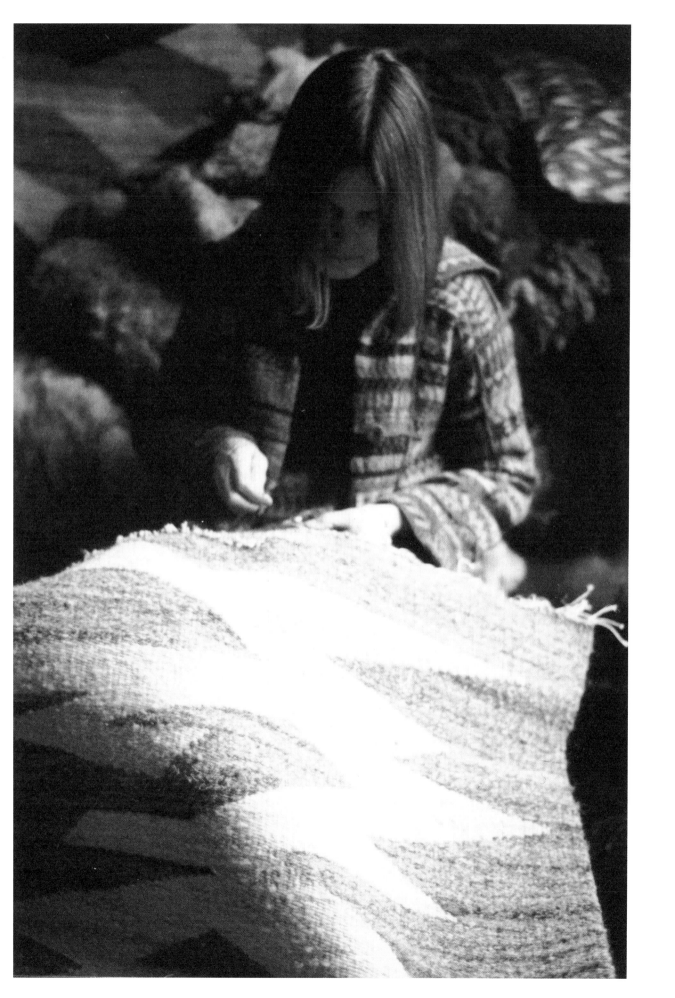

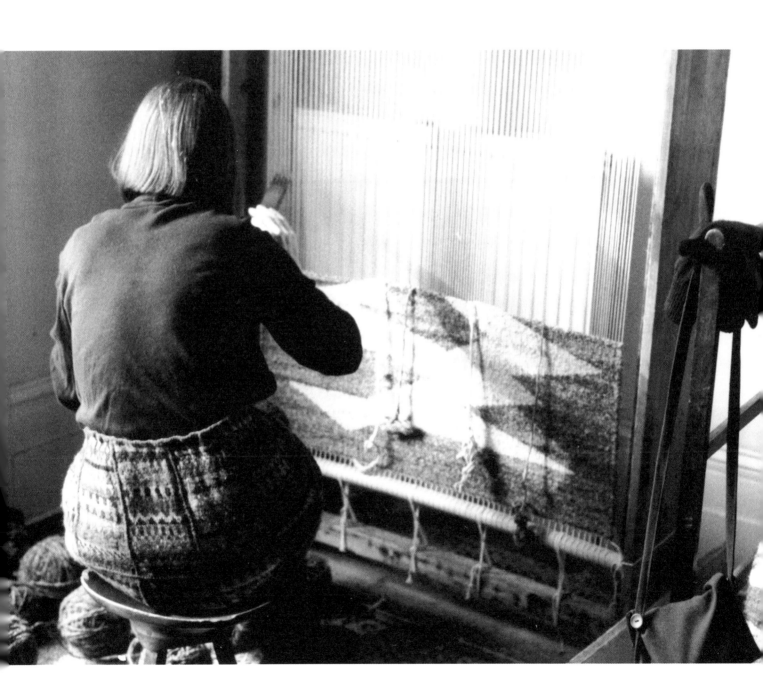

117 RACHEL SCOTT

My inspiration for starting to weave was an exhibition of Navajo blankets at the ICA in the early 1970s. I bought a book on Navajo weaving and my beater was made by my brother on the basis of an illustration in that book.

RACHEL SCOTT

JUDIT JUST

Judit Just (Barcelona, Spain, 1985) describes her colourful wall hangings as 'vibrant, fuzzy, spontaneous, joyful, fresh, flashy, rich and messy' – and even that overload of adjectives doesn't quite do them justice. Taking a mixture of cords, cotton threads, satin ribbons, vintage laces, fabric scraps, wool yarns, polyester and lurex strings, Just uses traditional rya knotting techniques on a lap loom or an 8-shaft table loom to weave richly textured collisions of colour, shape and materials. Inspired by the experience of synaesthesia, it's precisely the stuff that Instagram dreams are made of. 'I want to create intricate spaces and give people something beautiful to look at, so they can put their happy thoughts in their own happy landscape,' she says.

Just started weaving with her mother when she was a child, completing her first tapestry by the time she turned 11. She started a degree in fashion design but didn't finish it. 'I just didn't connect with it,' she explains. 'It was too conceptual – anyone can have an opinion on a dress; I wanted to actually make one.' She discovered sculpture and was immediately drawn in to its materiality and three-dimensional possibilities. 'With my hands and heart busy I was truly inspired to create what I do today,' she says. She enjoyed exploring new materials but missed textiles and returned to study textile arts. 'I am proud and lucky that I found a supportive creative place where I have learned how to create with fabrics, pattern designing, weaving and embroidering,' she says.

A move from her home country to the United States prompted a clear-out and an online sale and it wasn't long before she was receiving requests for custom commissions. 'After a bit of time and a lot of work, and with the creation of my Instagram account @_jujujust, everything suddenly exploded,' she says. 'That was at the beginning of the current "weaving wave" and I guess I was in the right place at the right time. Today, I am looking for the synaesthesic pleasure of touching colours, listening to textures, tasting shapes, and I want to share this experience and give people colourful goosebumps.'

Being from Barcelona has definitely instilled traditions and know-how that have left a permanent impression on me. Barcelona has always been a textile and fibre capital, and I am proud to be 'woven' by the city and its people. My family and community have surrounded me with tapestries and I want to contribute to all the beautiful things I grew up with.

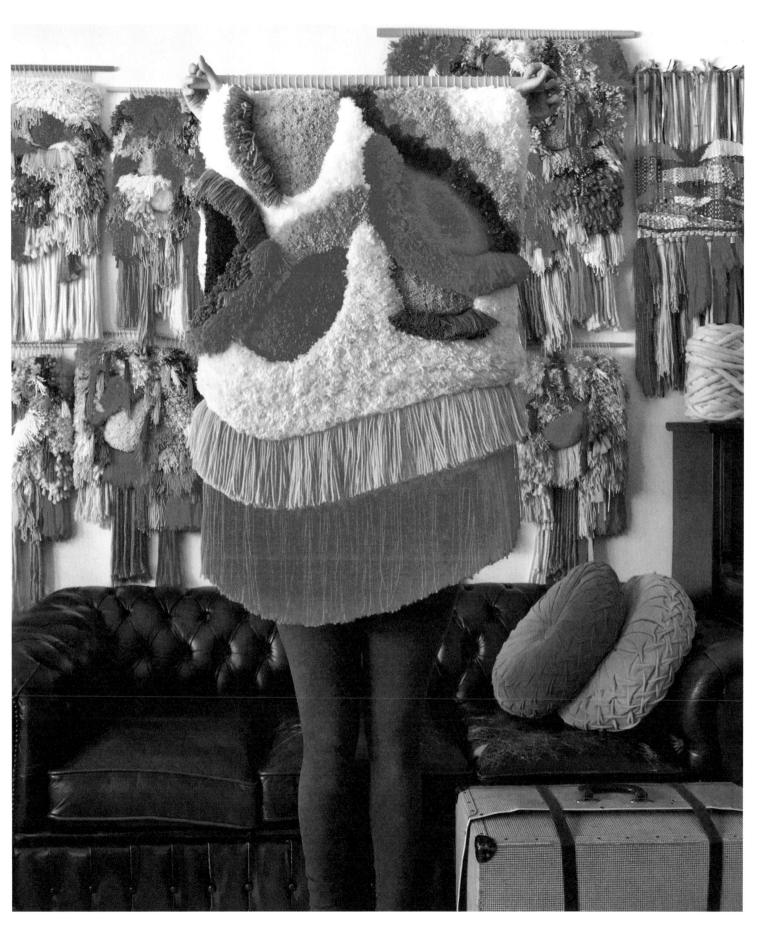

JUDIT JUST

I enjoy working with a mix of all kinds of materials: silk cords, cotton threads, satin ribbons, vintage laces, fabric scraps, wool yarns, polyester and lurex strings, and all kinds of vegetable fibres.

WEAVING ART OR CRAFT?

'I am going to forget, in order really to see them, that a group of Navajo blankets are only that. In order to consider them, as I feel they ought to be considered – as Art with a capital A – I am going to look at them as paintings – created with dye instead of pigment, on unstretched fabrics instead of canvas – by several nameless masters of abstract art.'[1]

127 When asked whether they would describe themselves as artists, craftspeople, weavers or designers, the makers profiled in this book gave starkly different responses, ranging from 'I am an artist' (Erin M. Riley, see p. 84) to 'I am a self-taught weaver' (Genevieve Griffiths, see p. 30) and everything in between, with the majority of answers being some variation on 'all of the above'. All of which poses the question, is weaving an art or a craft – and why does it matter?

The commonly used term 'arts and crafts' suggests a close relationship between the two words – and yet there is an implied hierarchy that goes beyond which word comes first. 'Part of the problem is that "art" has a positive evaluative connotation that "craft" lacks,' says philosopher Sally Markowitz.

> Some critics, with good reason, claim that this ... reflects our culture's elitist values: what white European men make is dignified by the label 'art', while what everyone else makes counts only as craft.[2]

1 A 'formalist critic' introducing the work of Navajo women, quoted in Parker, R. and Pollock, G. (1981) *Old Mistresses*. New York: Pantheon: 68

2 Markowitz, S. (1994) 'The Distinction between Art and Craft' in *The Journal of Aesthetic Education*. 28:1: 55–70

⊕ A Native American (Navajo) family poses near a timber and earth hogan near Bluff City, Utah, ca. 1880–1910.

Markowitz has explored the two most common differentiators between art and craft. The first, the 'aesthetic criterion', claims that artworks have inherent aesthetic value, and that although craft objects may also be aesthetically pleasing, their role as functional objects interferes with the appreciation of them as purely aesthetic objects. Alternatively put, art asks for nothing more than a contemplative response, whereas to truly appreciate what she calls craft's 'functional aesthetic' – often dependent on how well it performs its purpose – one must engage with its utility. To fully appreciate the beauty of a woven shawl, one must put it on – or at least see it worn. The second, the 'semantic criterion' suggests that art demands interpretation whereas craft only asks to be used, and so art is evaluated by what it is about, craft by what it is. It's easy to argue that craft meets either measure – as Markowitz says:

> If our criterion is an aesthetic one, surely many vessels and
> weavings, for example, will count; if our criterion is semantic,
> women's embroidery and much non-Western geometric design,
> often dismissed as merely decorative, may count as well.[3]

128

However, this raises an interesting question: if so much craft meets the criteria of art, why isn't it considered art? When art historian Glenn Adamson said 'Craft is a word that people throw at things made by non-white people and women,' he touched on an issue relevant to many of the weavers in this book, not least Kayla Mattes, who agrees: 'There's a lot of historical baggage regarding the separation of art and craft; a split that's definitely tied to gender.' Adamson continues:

> It's really useful to reverse the polarity and instead of saying "why
> do women make craft?", the question should be "why do we call
> the things women make craft?" and not assume that's a natural
> category but instead assume it's a constructed category that
> already has power dimensions built into it – and the same thing
> with black people, Asians and Latin Americans who again are
> often thought of as fundamentally based in crafts.[4]

3 Markowitz, S. (1994) 'The Distinction between Art and Craft'
 in *The Journal of Aesthetic Education*. 28:1: 55–70

4 In conversation with Grant Gibson as part of Crafts Book Club
 Available online: craftscouncil.org.uk/articles/crafts-book-club-glenn-adamson

It is an important realisation that gets to the heart of why the difference between art and craft matters.

Both the 'aesthetic criterion' and 'semantic criterion' evaluated by Markowitz prioritise the mental over the physical, reflecting a hierarchy of the senses that has been around since Aristotle claimed that sight 'approximates the intellect most closely'.[5] By the time of the Renaissance, when the senses were categorised into a strict hierarchy, not only was sight at the top, but touch was at the bottom. It wasn't long before the hierarchy of thinking and making followed suit. Royal Academician Joshua Reynolds may have been a lone voice when he first argued that although an artist might start his training learning manual skills, he only really became accomplished once he had mastered 'the grandeur of his ideas',[6] but he started a move towards equating head knowledge with art and hand knowledge with craft. In 1747, when Robert Campbell's guide to trade professions, *The London Tradesman*, was published, swiftly followed by a slew of 'pattern books' from the likes of Thomas Chippendale, the design process was taken out of the hands of makers and into the heads of draughtsmen.

By the end of the 18th century, professionalism and draughtsmanship became synonymous as technical drawing skills became increasingly important in the modernisation of fields as diverse as medicine and navigation. As rococo flourishes fell out of favour and geometric forms that were more easily replicated from a drawing came into fashion, the role of the craftsman was further diminished – now increasingly 'called upon to fill the gap between sketch and product'.[7] The history of weaving reflects a similar shift, as developing technology took control out of the hands of individual weavers. In tapestry the first part of the process has always been the production of a *mise en carte* or cartoon – a detailed drawing or painting of the design to be produced, which is translated into the colours for the yarn and used as a guide for the weavers, representing a separation of skills, but the weaving was still highly skilled. The introduction of Jacquard looms meant that pre-programmed punch-cards dictated every detail of the fabric's pattern and reduced the role of the weaver to one of execution.

129

5 Pallasmaa, J. (2012) *The Eyes of the Skin: Architecture and the Senses.* Chichester: John Wiley & Sons: 17

6 Adamson, G. (2007) *Thinking through Craft.* London / New York: Berg: 11

7 Ibid.

Despite the early Bauhaus ambition for 'art–craft' unity, weaving was described as an area of 'craft training' even in Walter Gropius' first manifesto published in 1919. As a craft – with a specific set of materials, technologies and structures – weaving was therefore considered inferior to art from day one. Much of the early work at the Bauhaus reflected this – students such as Hedwig Jungnik, Lore Leudesdorff and Ida Kerkovius came to the weaving workshop with a predetermined idea of the image they wanted to create (often inspired by the work of painters at the school such as Wassily Kandinsky and Paul Klee) and wove what were essentially 'picture[s] made of wool'[8] in which the risk and experimentation was complete before they sat down at the loom – what David Pye terms the 'workmanship of certainty'.

8 Smith, T. (2004) *Bauhaus Weaving Theory*. London: University of Minnesota Press: XVI

⊕ Group portrait of weavers with master weaver Wanke in the weaving workshop, Bauhaus Dessau, 1928. First row, from left to right: Lotte Beese, Anni Albers, Lijuba Monastirsky, Rosa Berger, Gunta Stölzl, Otti Berger, Kurt Wanke. Upper row, from left to right: Lisbeth Birmann-Oestreicher, Gertrud Preiswerk, Helene Bergner (Léna Meyer-Bergner), Grete Reichardt.

Umfang der Lehre.

Die Lehre im Bauhaus umfaßt alle praktischen und wissenschaftlichen Gebiete des bildnerischen Schaffens.

A. Baukunst,
B. Malerei,
C. Bildhauerei

einschließlich aller handwerklichen Zweiggebiete.

Die Studierenden werden sowol handwerklich (1) wie zeichnerisch-malerisch (2) und wissenschaftlich-theoretisch (3) ausgebildet.

1. Die handwerkliche Ausbildung — sei es in eigenen allmählich zu ergänzenden, oder fremden durch Lehrvertrag verpflichteten Werkstätten — erstreckt sich auf:

a) Bildhauer, Steinmetzen, Stukkatöre, Holzbildhauer, Keramiker, Gipsgießer,
b) Schmiede, Schlosser, Gießer, her,
c) Tischler,
d) Dekorationsmaler, Glasmaler, Mosaiker, Emallöre,
e) Radierer, Holzschneider, Lithographen, Kunstdrucker, Ziselöre,
f) Weber.

Die handwerkliche Ausbildung bildet das Fundament der Lehre im Bauhause. Jeder Studierende soll ein Handwerk erlernen.

2. Die zeichnerische und malerische Ausbildung erstreckt sich auf:

a) Freies Skizzieren aus dem Gedächtnis und der Fantasie,
b) Zeichnen und Malen nach Köpfen, Akten und Tieren,
c) Zeichnen und Malen von Landschaften, Figuren, Pflanzen und Stilleben,
d) Komponieren,
e) Ausführen von Wandbildern, Tafelbildern und Bilderschreinen,
f) Entwerfen von Ornamenten,
g) Schriftzeichnen,
h) Konstruktions- und Projektionszeichnen,
i) Entwerfen von Außen-, Garten- und Innenarchitekturen,
k) Entwerfen von Möbeln und Gebrauchsgegenständen.

3. Die wissenschaftlich-theoretische Ausbildung erstreckt sich auf:

a) Kunstgeschichte — nicht im Sinne von Stilgeschichte vorgetragen, sondern zur lebendigen Erkenntnis historischer Arbeitsweisen und Techniken,
b) Materialkunde,
c) Anatomie — am lebenden Modell,
d) physikalische und chemische Farbenlehre,
e) rationelles Malverfahren,
f) Grundbegriffe von Buchführung, Vertragsabschlüssen, Verdingungen,
g) allgemein interessante Einzelvorträge aus allen Gebieten der Kunst und Wissenschaft.

Einteilung der Lehre.

Die Ausbildung ist in drei Lehrgänge eingeteilt:

I. Lehrgang für Lehrlinge,
II. „ „ Gesellen,
III. „ „ Jungmeister.

Die Einzelausbildung bleibt dem Ermessen der einzelnen Meister im Rahmen des allgemeinen Programms und des in jedem Semester neu aufzustellenden Arbeitsverteilungsplanes überlassen.

Um den Studierenden eine möglichst vielseitige, umfassende technische und künstlerische Ausbildung zuteil werden zu lassen, wird der Arbeitsverteilungsplan zeitlich so eingeteilt, daß jeder angehende Architekt, Maler oder Bildhauer auch an einem Teil der anderen Lehrgänge teilnehmen kann.

Aufnahme.

Aufgenommen wird jede unbescholtene Person ohne Rücksicht auf Alter und Geschlecht, deren Vorbildung vom Meisterrat des Bauhauses als ausreichend erachtet wird, und soweit es der Raum zuläßt. Das Lehrgeld beträgt jährlich 180 Mark (es soll mit steigendem Verdienst des Bauhauses allmählich ganz verschwinden). Außerdem ist eine einmalige Aufnahmegebühr von 20 Mark zu zahlen. Ausländer zahlen den doppelten Betrag. Anfragen sind an das Sekretariat des Staatlichen Bauhauses in Weimar zu richten.

APRIL 1919.

Die Leitung des
Staatlichen Bauhauses in Weimar:
Walter Gropius.

Walter Gropius' Bauhaus manifesto and programme (page 4), April 1919

nr. 5.
matrazenstoff(jacquarddrell)
material: kette b'wolle,schuss leinen
bindung: atlas-köper,jacquard
dichte: 40K 28S
ausrüstung: mangeln.
preis: 120 cm br. rm 6,50

nr.6.
matrazenstoff (grau)
material: kette-b'wolle,schuss leinen
 ungebleicht,
bindung: 5b atlas
dichte: 44 à cm K 24S
ausrüstung: schlichte-mangeln,
preis: 120 cm br. rm 5,75

nr.7.
i n l e t t .
material: b'wolle, gefüllt
bindung: köper,
dichte: 48 K
ausrüstung: imprägnieren,färben
 mangeln,
verwendung: kissen,federbett,
preis: 8o cm br. rm 4,50
 " 130 " " " 7,50

nr 8
einschütte:material:b'wolle kette u.schuss
 bindung:leinen
 dichte: kette schuss
 ausrüstung: rohweiss gewebt spezielle
 appretur-fedrdicht!
 verwendung: steppdecke etc
 preis: 6ocm br. 2.5or m

Günta Stölzl, teaching material, after 1925

133 Weaving students Anni Albers and Gunta Stölzl favoured the 'workmanship
of risk' in which weavers made and continuously recalibrated decisions
about their design throughout the making process in response to
materials, technique and structure. In 1924, Albers published *Bauhaus
Weaving*, a manifesto that called for weaving to be explored through direct
experimentation on the loom, contrary to contemporary methods of textile
design in which mechanisation had separated the designer from the loom.
She argued that it was necessary to 'begin again'[9] and reconnect craft and
design so that they became interdependent once more. Stölzl's *Weaving at
the Bauhaus* followed in 1926, seeking to align the weaving workshop she
was now running with the new 'principles of Bauhaus production' – in
which Gropius turned away from the school's early commitment to craft
and towards production for industry. Rejecting the parallels with painting
and instead allying the weaving workshop to architecture, Stölzl stated that
'a woven piece is always a serviceable object, which is equally determined
by its function as well as its means of production'[10] and modern weaving
theory came out of such texts. She might have come down on the side of
functionality, but by defining woven objects through both their process and

9 Smith, T. (2004) *Bauhaus Weaving Theory*. London: University of Minnesota Press: XVII

10 Ibid: XVI

⊕ **Otti Berger**, 'Tasttafel', from Moholy-Nagy's preliminary course, Winter semester 1927/1928

their outcome, Stölzl started to make a case for weaving to be defined on its own terms, rather than by what it lacked when compared to paintings. Glenn Adamson argues that it is perhaps better to think of weaving as a process akin to photography, the result of which can be functional or a work of art, depending on its application. Although this is a logical approach, it doesn't resolve the problem of the stubborn hierarchy that exists within both materials and applications.

As craft becomes more popular and people increasingly value its inherent qualities such as tactility, workmanship and materiality, perhaps art will be defined by what it lacks in comparison to craft rather than vice versa. As Markowitz says, 'Why should we assume that art objects are necessarily more valuable than mere things, especially when the things are beautiful, carefully made, useful bearers of tradition?'[11]

134

11 Markowitz, S. (1994) 'The Distinction between Art and Craft'
 in *The Journal of Aesthetic Education*. 28:1: 55–70

⊕ **Hedwig Jungnik**, Gobelin wall hanging (detail), 1921–1922. Wool, linen, cotton, chenille, rayon and silver thread

BRENT WADDEN

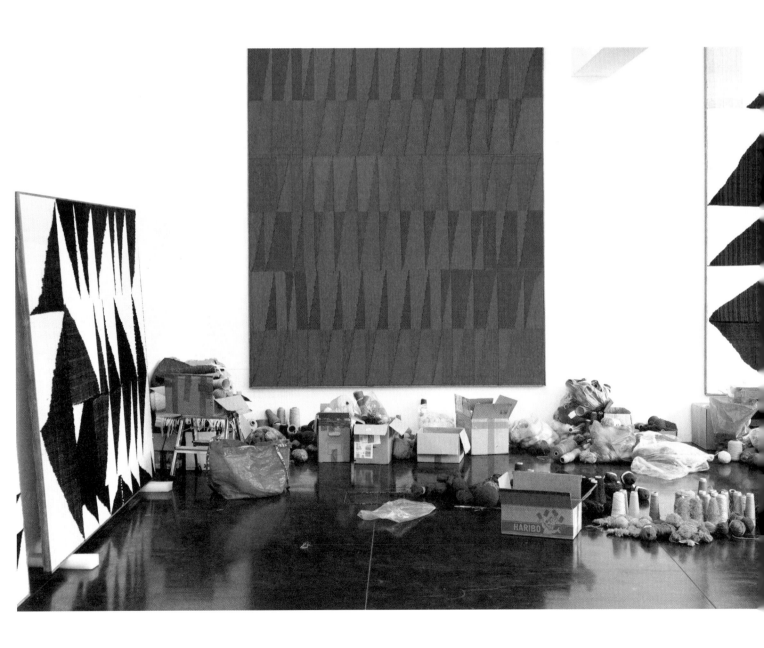

Brent Wadden (Glace Bay, Canada, 1979) describes his woven textiles as 'paintings' – something underscored by both their echoes of the abstract work of artists such as Agnes Martin and Bridget Riley, and their inclusion in galleries in London, Paris and New York. 'I find it strange that we hold certain handmade objects on one side of a spectrum, and fine art on the other,' he says. 'I stretch and frame textiles as if they were paintings [and] try to blur the divide between fine art and craft.' Appropriating domestic objects traditionally made by anonymous women and people of colour and representing them as art is perhaps problematic in the hands of a white male artist, but Wadden argues, 'My book about the weaving department at the Bauhaus is one of my most prized possessions. I learned about Anni Albers and the other talented women there, but I also learned that they were discriminated against and that reality really left a mark on me. Challenging the craft/art spectrum is a worthwhile endeavour – and hopefully my work helps to shift how people think about weaving.'

Having grown up in a working-class family, a frugal approach to sourcing yarn is deeply ingrained in Wadden's practice – he buys his yarn second-hand or unravels knitted and crocheted blankets and clothing. 'Vintage materials are much more interesting to work with,' he says. 'Reusing material offers something different – often the yarn tells me what to do with it.' His design process starts with sorting through his bins of yarn, organising them into complementary hues. 'I make coloured pencil sketches to plan out the use of materials I have collected from different places.'

He started weaving when friends suggested his artwork would translate well to textiles and he got in touch with Berlin-based Travis Meinolf. 'He taught me on one of his tiny laser-cut back-strap looms and I used that for a year before returning to

Travis' studio with the urge to work on something bigger,' says Wadden. 'It was a huge learning curve, but before long I purchased my first real floor loom and I slowly started acquiring all the necessary tools and gadgets. At some point I was in my studio – now filled with looms and supplies – and I suddenly thought, "Holy shit, I'm a weaver!"'

BRENT WADDEN

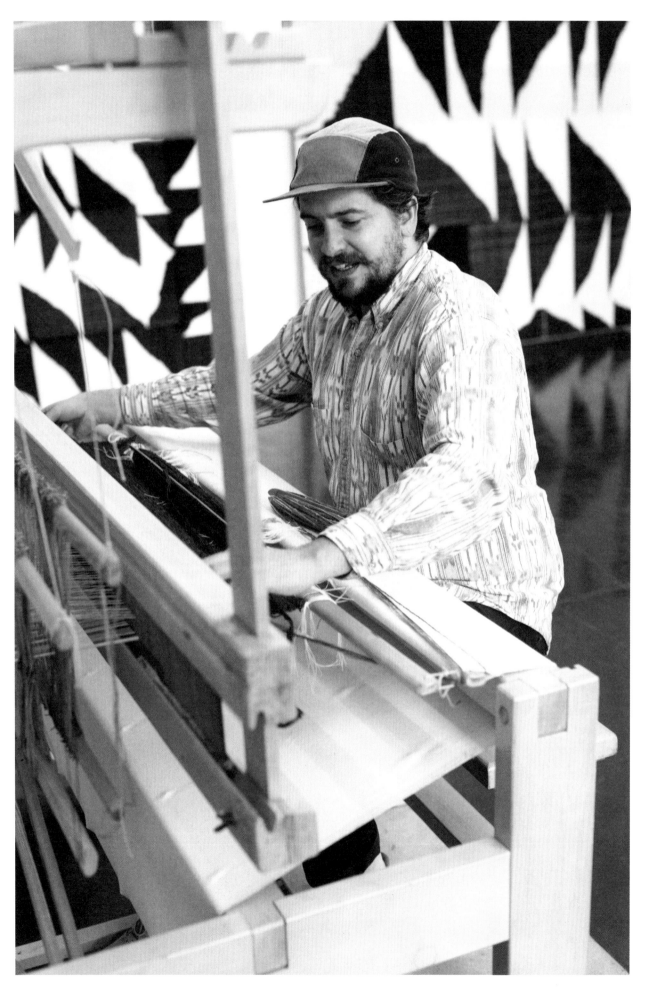

Unrolling the completed panels from the loom always brings a huge surprise – there is excitement around the unknown. There are times in the process when I wonder if a weaving will even work out, but I have come to accept changes to the plan, and mistakes too. I've noticed that these mistakes are part of what becomes attractive to the viewer. They are points of interest.

I was first interested in learning how to make weavings because of how they are often viewed as craft objects instead of fine art, which is in contrast to how oil painting is perceived. I find it strange that we hold certain handmade objects on one side of a spectrum, and fine art on the other. Challenging the craft/art spectrum is a worthwhile endeavour – and hopefully my work helps to shift how people think about weaving.

Some artists can make multiple works in a day, but my production is limited to about one work per week depending on the scale. It keeps me grounded – I never feel alienated from my own work. I could try to produce the same weaving twice but because of the variations in materials and the natural mistakes, each work is inevitably its own.

BRENT WADDEN

RACHEL SNACK

Rachel Snack (New Jersey, United States, 1990) is the founder of textile and weaving studio Weaver House Co. and also Creative Director of Harrisville Designs, founded in 1971 to preserve a local woollen-mill tradition that dates back to 1794. Her own weaving is inspired by her surroundings and the meditative movement of the process. 'I feel most at home intuitively creating at the loom, unconsciously drawing from my surroundings and in motion, yet in place,' she says. Snack began her career as an artist in painting and ceramics, but discovered weaving through an introductory textiles class in the Fibre and Material Studies department at the School of the Art Institute of Chicago (SAIC). 'There was a kinship I felt the first time I attempted to weave cloth – I was tasked with creating a small sample and instead sat at the loom for hours, embracing the way my body and the loom worked together.' This moment of epiphany spurred a decision to focus on weaving during her undergraduate studies and later pursue it as a career.

Her woven artwork has a spiritual dimension to it, informed by the way she feels as she works. 'My weavings celebrate the quiet and often missed moments in life, the sacred space of the loom, the concept of weaving in infinity and the tactile vessel,' she explains. 'They are made on the loom in connection to the grid, to craft a relationship with the body and create a religion of space apart from the loom. They are my identity, my routine, my rite of passage.'

With natural yarns such as cotton, linen and wool – sourced sustainably and organically in the United States – she uses several 8 to 12-harness floor looms and techniques such as pick-up, supplemental weft, double-cloth and ikat resist dyeing to create understated pieces in neutral colour palettes. 'My practice is intuitive, responsive – I used to believe that making a mistake during the process that would cause an imperfection in the cloth

was the most heart-breaking aspect of weaving,' she says. 'Now I celebrate these imperfections, preserving them as a marker of the human hand. Textiles remember, and my work creates a physical memory bearing witness to the hand of the artist, becoming material evidence of touch.'

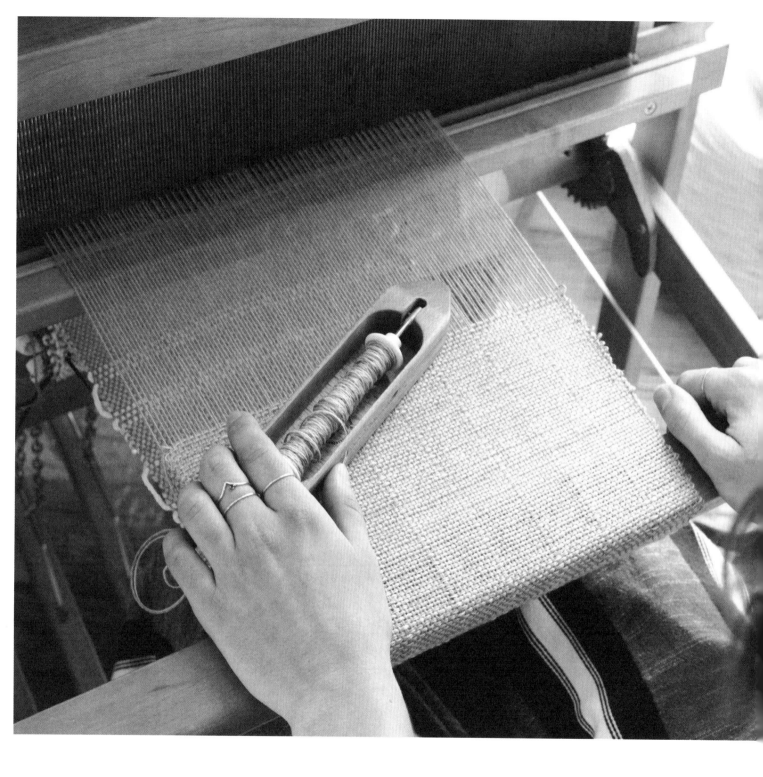

The first loom I ever wove on was a 4-harness table top loom, which meant I had yet to be introduced to foot treadling straight away. I was immediately hooked – the studio cleared, the city quietened, and I continued to weave.

RACHEL SNACK

RACHEL SNACK

My practice is intuitive, responsive and anchored in textile history. I see the loom as an instrument, and as a maker I push the boundaries of this tool, finding new ways to approach textile-making.

155 RACHEL SNACK

DIENKE DEKKER

Dienke Dekker (Maastricht, The Netherlands, 1989) works as a weave designer for German-based interior-textile design company Kinnasand (a subsidiary of the Danish textile corporation Kvadrat) and also creates independent work as a textiles artist, which varies from experimental research projects to three-dimensional sculptures. Describing her work as 'a mix between rational and intuitive', she says she weaves 'as an answer to my curiosity and the longing to explore as much as possible within the field of textiles'.

The variety of her work means that she works with a multitude of different looms, ranging from industrial looms such as the Jacquard, dobby and leno, to hand, shuttle and Punja looms. Yarn varies too: 'If I work on commercial rugs I often work with wool as it has the perfect properties for this function and new yarn development can be expensive and time consuming', she says. 'However, when I'm working on curtains or my own free work, every material and yarn can be interesting.' For her 'Union of Striped Yarns' project, Dekker made her own yarns in Tilburg's Textile Museum. 'I used an ancient rope machine to twine bunches of thin, contrasting-coloured cotton into thick ropes, which I used as warp and weft in a flat weave.' This student project has since

been developed into Waan, a commercial product for GAN rugs, for which the cotton yarns have been replaced with an industrial, thick felted fibre.

It is this experimental approach that informs all of Dekker's work, exploring technique, materiality and process – much as Anni Albers and Gunta Stölzl did in the Bauhaus weaving workshop. 'Most projects start with the longing to explore a certain technique,' she says. 'I will study this technique and then start altering the parameters. I reflect on the outcome and repeat this process until I feel I have explored most directions and have reached something interesting.' Craftsmanship is important to Dekker too: 'I admire every other weaver who weaves with care, from the weaver whose work is hanging in a museum to the weaver who makes his or her own scarf.'

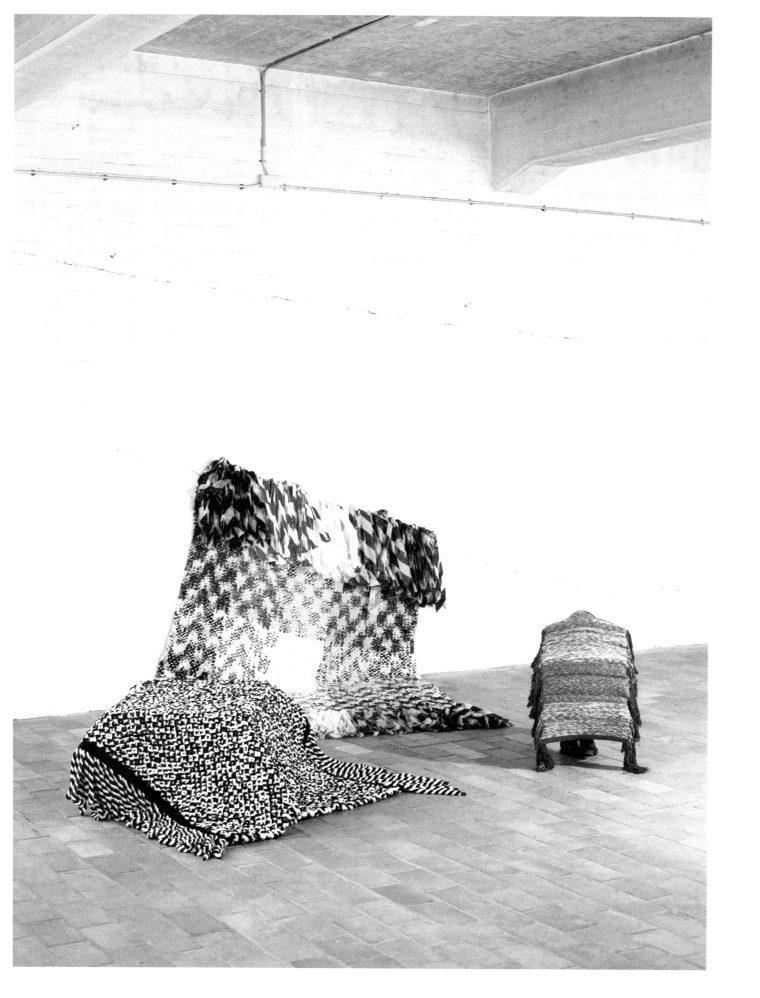

I don't enjoy setting up the warp, but from there on it only gets better. I love the way my loom feels – it is the perfect extension of the body. I own a simple wooden dobby loom which fits the proportions of my body perfectly. Moving the shafts with my legs, inserting the weft with my arms, leaning back to make the weaving thicker with the reed ... to see a weaving slowly appear from this rhythm is a wonderful and addictive thing.

Sourcing interesting industrial yarns is not easy, but the cost of developing a new yarn is high and often only possible only in large quantities. So I experiment myself first, making small amounts of yarn, to see how it functions. It is far easier to persuade a producer to develop an industrial version if the results of my tests are good.

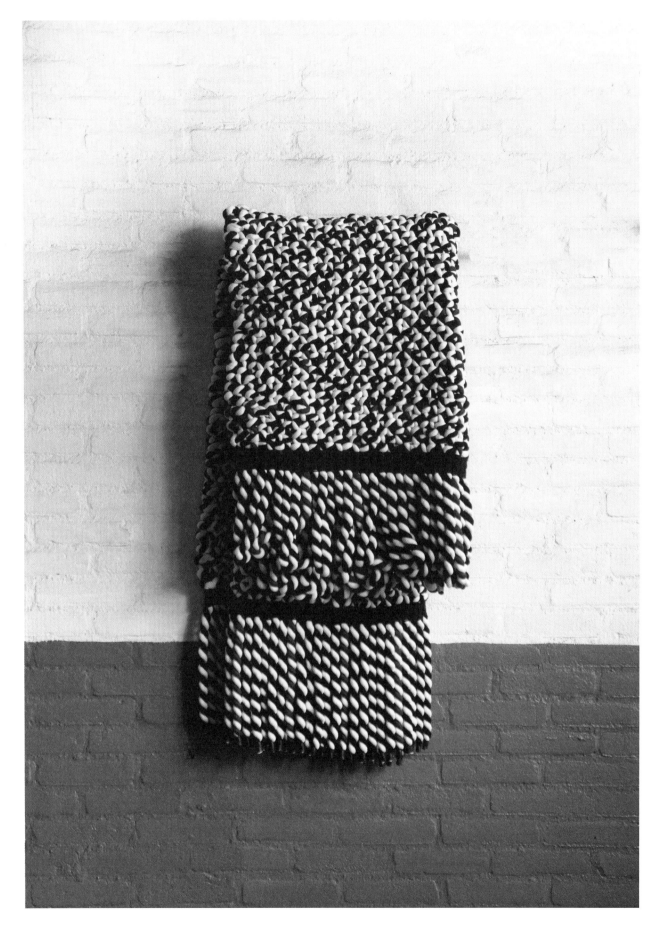

161 DIENKE DEKKER

Sometimes I work on industrial looms such as Jacquard, dobby, and leno looms, but I also use handlooms and shuttle looms. Yarns and materials vary a lot, depending on the project I am working on and what purpose it has. If I work on commercial rugs I often use wool as it has the perfect properties for this function. However, when I'm developing my own free work, every material and yarn has potential.

CHRISTY MATSON

Christy Matson (Washington State, United States, 1979) hand-weaves gallery pieces using a Norwegian TC2 Jacquard loom, blending traditional warp yarns such as alpaca and linen with experimental weft materials such as copper wire, stainless steel, drawstrings and yarn made from unspun paper. 'I'm a yarn hoarder,' she laughs. 'Any time I come across a potential material, I hold on to it.' Her current collection includes mill ends and 'deadstock' from the fashion industry, yarn her mentor Lia Cook bought decades ago in Japan, and naturally dyed 'spaghetti yarn' left over from a collaboration. 'The hunt for unusual weft yarns is a big part of what I do. Lately, I've been painting them too.'

Matson started weaving 20 years ago at the University of Washington in Seattle, having sought out the fibre department after seeing hand-weaving while travelling in Nepal. 'Although it wasn't until I met the Jacquard loom a few years later that I knew I'd found my tool,' she says. 'It didn't hurt that I learned from Bethanne Knudson

– the most passionate and knowledgeable teacher of woven structure I have ever met.'

The Jacquard process requires pre-planning, so Matson starts by drawing, creating watercolour washes or collaging scraps of opaque paper. She typically creates multiple sketches that she layers over one another before scanning them into Photoshop and translating them into weave structures. 'There is a lot of trial and error as I go back and forth from computer to loom testing things out,' she says. 'I often spend as long drafting structures as I do weaving.'

And yet, despite all that planning, the weaving process is far from predetermined. 'I enjoy interrupting structures, being nimble with my material choices and making decisions on the fly,' she says. 'My approach to weaving is akin to drawing – my handloom is just the conduit through which I make marks.'

I think about what I do at the loom as being akin to drawing
and my handloom is the conduit through which I am able to make
marks. I tend to gravitate towards things that are made by hand
because they often possess certain qualities the industrially made
objects simply cannot replicate. I like it when things are imperfect
and irregular.

With the exception of finishing up the edges at the end, I love the entire process of weaving. I love how immersive and time consuming it is. It's like entering into a deep reciprocal relationship with the tools, with the materials and with the compositions.

CHRISTY MATSON

I tend to start with something very abstract, sometimes it's a visual I see in my head or a texture I sense with my fingers – and I can spend almost as much time working out the structures as I do weaving each piece.

ELEANOR PRITCHARD

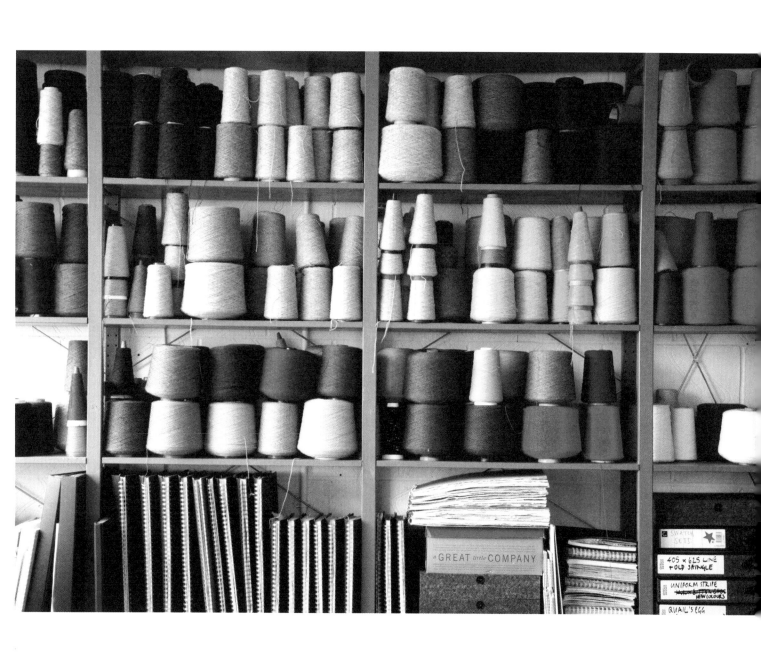

and undyed woollen blankets are woven on Dornier rapier looms at a mill in Lancashire; and our upholstery fabrics are woven for us by a specialist mill on the Isle of Bute off the west coast of Scotland.'

Every design starts with a storyboard made using photographs, drawings and colour references. 'I look at found repeat patterns in the urban environment,' she says. 'I always carry a sketchbook with me.' The next stage is a hand-drawn design, combined with paper collages to explore pattern, repeat and scale. Once the pattern is designed, Pritchard moves onto 'the maths' and writing up the notes for the loom. After that she makes the warp, winds and threads it, pegs the lags and finally she weaves the samples. 'Although much is planned before I start weaving, things always change and develop on the loom,' she says.

Pritchard understands the appeal of the handmade and enjoys being hands-on in her own design process but doesn't advocate a return to making everything by hand. 'I really like the mix of hands-on design followed by power-loom production,' she says. 'I think that good design and good weaving should be accessible to a broader public, beyond the niche of craft galleries.'

Eleanor Pritchard (Bangalore, India, 1971) runs her weaving studio from a sunny workshop in London, designing weave patterns and producing samples for production in the UK. Her studio's designs are characterised by a pared-back geometry, graphic reversible patterns and a colour palette that combines chalky and cross-hatched neutrals, sharp accents and deep inky tones. 'I like exploring colour and pattern,' she says. 'My aesthetic is contemporary with a nod to British mid-century design – I feel a strong affinity for the aesthetics and philosophy of this era. I also have a deep interest in vernacular British textiles and I see my work as a re-interpretation of these traditions and techniques for today's audience.'

Pritchard works with well-respected and highly skilled British weavers in the UK to make blankets, cushions and upholstery fabric for furniture. 'I do all of the design and sampling in the studio and then commission mills to weave the production runs,' she says. 'Most of our woollen blankets are woven on Dobcross shuttle looms at a small traditional mill in west Wales; our lambswool

I like the problem-solving aspects of weaving – the fact that it is a
mix of understanding how structures work alongside an intuition for
colour and pattern. I also really like the parameters which weaving
imposes – I find the restrictions very stimulating.

ELEANOR PRITCHARD

I would describe myself as a weave designer. I do all of the design myself, sampling in the studio, and then I commission mills to weave the production runs. Within my process, the design is the creative part and the production is more mechanical.

ELEANOR PRITCHARD

WEAVING FUTURES

'There is really nothing new to discover in weaving,
it is merely an evolution.'
— GERD HAY-EDIE, MOURNE TEXTILES [1]

Weaving is at once ancient and cutting-edge. Despite following the same basic formula of combining perpendicular warps and wefts for millennia, weaving has always flirted with the future, from its early industrialisation to the influence of Jacquard loom punch-cards on contemporary computing. So what next for this venerable craft? The development of three-dimensional weaving, the advent of 'smart' textiles, the emerging impact of the 'circular economy' and the idea of 'growing' fabric are just four ways in which weaving is evolving its way into the future.

Nigerian-American designer Oluwaseyi Sosanya has invented a loom that weaves in three dimensions, intertwining layers of flat warp threads with perpendicular weft patterns at different heights, providing both the second and the third dimensions. Feeding yarn through tubes, the loom wraps it around a grid of vertical poles, relying on a process similar to three-dimensional printing. 'I looked at a few different machines when designing this one and got most inspiration from a sewing machine and an industrial knitting machine,' says Sosanya. 'Both allow thread to move freely through the mechanics, using springs and guiding to hold the tension. I coded a bit

1 Selvedge Magazine. Available online: www.selvedge.org/blogs/selvedge/margaret-howell-mourne-textiles

⊙ Tools and weavings made from electronic waste. From **Jorien Wiltenburg**'s Micro Urban Mining project, 2015

of software that allows any solid geometry to be split into layers and woven – once the first row is layered, the thread maintains its tension, due to guide tubes and an initial winding of the thread programmed to run before the weaving of each structure.'[2] Sosanya has already collaborated with footwear designers Lixian Teng and Tomiwa Adeosun to create a shoe sole woven from natural fibres and dipped in silicone to maintain its structural properties, but he predicts a wider range of applications – from medical implants to architectural structures, and air-purification systems to stab-proof vests.

2 Treggiden, K. (2014) 'Oluwaseyi Sosanya invents 3D-weaving Machine' *Dezeen*. Available online: www.dezeen.com/2014/06/23/oluwaseyi-sosanya-invents-3d-weaving-machine-show-rca-2014

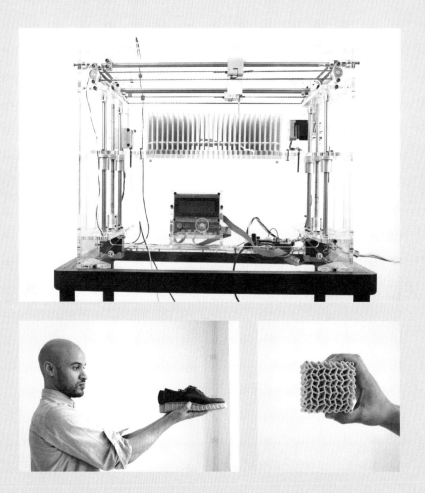

⊕ Royal College of Art (RCA) graduate **Oluwaseyi Sosanya** has created a loom that can weave in three dimensions and used it to create a shoe sole, presented at the institution's annual degree show in 2014.

181

Three-dimensional fabrics can also be created using more traditional techniques. So-called 'loom disruptor' Philippa Brock fabricates such materials using industrial Jacquard power looms programmed with computer aided design (CAD) and computer-aided manufacturing (CAM) software. She either incorporates elasticated yarn or weaves interconnected layers, so that, although woven flat, the resulting fabric snaps into three dimensions once released from the loom. 'The inspiration behind the pieces was Sir Aaron Klug's Nobel Prize paper exploring the results of X-ray crystallography tilting methods which allowed him to work out the structure of helical and spherical viruses,' she says. 'The concept of self-assembly is used to explain virus formation. [My] woven pieces self-assemble through yarn and structure interactions when tension is taken off the loom, transforming two-dimensional flat pattern into three-dimensional fabric.'[3] She is currently exploring commercial applications for the materials created using such methods in the belief that three-dimensional weaving represents the future for the craft.

Anon. (2011) 'Self Assembly – Philippa Brock'
 Available online: onviewonline.craftscouncil.org.uk/4040/object/T173

⊕ **Philippa Brock**, work from the 1580: *Volume and Space in the Third Dimension Self Fold* series, 2012. Woven at Gainsborough Silk Weaving Company using their Bonas Dataweave loom.

Meanwhile, ancient Bolivian weaving techniques are being used to create three-dimensional cardiac implants for children with congenital heart issues – those born with a 'hole' in their hearts. Inspired by his grandmother's weaving skills, cardiologist Franz Freudenthal invented the top-hat-shaped 'stopper', which is woven from a single strand of nitinol – a highly elastic nickel–titanium alloy with shape memory – and travels through blood vessels to the heart via a catheter inserted in the groin, opening out only when it arrives in the right place, filling the hole and staying put for life. The implant cannot be mass produced – only Bolivia's Aymara women with their unique weaving techniques have the skill and dexterity required, and even they undergo four months' training in the lab to perfect Freudenthal's device. The implant is particularly important to Bolivian children who not only live at an altitude that exacerbates such heart conditions, but also within a culture where some indigenous communities believe that open-heart surgery damages the soul – so a uniquely Bolivian technique has been able to solve a uniquely Bolivian problem. Today, 40 women weave 250 to 300 devices a month, saving thousands of children each year.

182

Smart textiles are also saving lives. Anyone who came of age in the early 1990s will remember heat-sensitive clothing brand Hypercolor, whose t-shirts changed colour in response to temperature, with often somewhat embarrassing results. The technology has moved on – and smart textiles can

⊕ Bolivian weavers offer medical science invaluable help with unique hand-woven survival devices for children with congenital heart disease, in Bolivia and in other parts of the world.

now detect and respond to not only thermal inputs but also to mechanical, magnetic, chemical, electrical and other signals, with life-changing results. Using three-dimensional weaving in combination with smart textiles, Swedish designer Siw Eriksson has developed a prototype for a textile cap that promises to simplify and improve brain activity measurement in premature babies. Currently, electrodes are applied to the skull, which requires precision and can damage the babies' highly sensitive skin. 'We wanted to investigate whether a better and more adapted method of skin-sensitive electrodes could be applied, where all the electrodes can be applied simultaneously by being in one structure,' says Eriksson. His prototype enables the different components of the cap to be woven simultaneously, making it not only simpler, safer and more efficient, but also more cost effective and environmentally friendly.

The environment is a growing area of concern across textiles innovation and focus is now on the circular economy or 'cradle to cradle' – a term coined in the 1970s by Swiss architect Walter R. Sahel and redefined by Michael Braungart and William McDonough in *Cradle to Cradle: Remaking the Way We Make Things* (2002). They argue that a product's end of life must be considered in its initial design, so that its components either biodegrade or can be returned to industrial processes as high-quality raw materials for new products – and it's worth noting the insistence on 'high-quality', as recycling into less valuable products, or 'down-cycling', only postpones the issue. As McDonough puts it, 'products should be "gifts for the future", not materials destined for landfill'.[4]

It starts with reducing waste. Lauren Chang (see p. 98) tries to eliminate waste altogether by working closely with farmers and shepherds to develop an in-depth understanding of what goes into her raw materials not only physically but also in terms of human effort. 'Working directly from the fleece enables me to use every bit of fibre,' she says. 'So much fibre is wasted in processing and some parts of a fleece are just not considered desirable – a lot never even makes it to the mill. But each part of the fleece has a use.' She spins from 'flicked locks' avoiding the need for a drumcarder, hand card or comb, and repurposes any unavoidable waste as compost or stuffing for scented lavender bags she sends out with her woven products. It might not

4 Mcdonough, W. and Braungart, M. (2002) *Cradle to Cradle: Remaking the Way We Make Things*. New York: Farrar, Straus and Giroux.

sound cutting-edge, but Chang argues that the solutions for contemporary problems can be found in traditional techniques. 'Focusing on the origin of materials and supporting agriculture are, in my opinion, two of the most future-focused perspectives in weaving today,' she says. California-based FiberShed is working on a similar model on a larger scale, pioneering 'soil-to-soil' communities that ensure all their textiles waste goes back into the ground as compost.

The next step is using pre-existing waste as a raw material – which is certainly nothing new; rag rugs have employed this approach for generations. But today, it is argued that enough waste textiles have already been produced to support our needs indefinitely. Many of the weavers profiled in this book use yarn left over from industry, source their yarn second-hand or find other ways to divert textiles from landfill and onto their looms. According to one estimate, there is up to fifty times more gold and precious metal in existing electronic waste than in ore that could be mined from the ground – it might seem an unlikely source of yarn, but with 10% of global gold production and a third of silver going into electronics, only a fifth of which are recycled, electronic waste is a huge untapped resource. In her Micro Urban Mining

184

⊕ **Jorien Wiltenburg**, Micro Urban Mining project, 2015. Weavings made from electronic waste

concept, Willem de Kooning Academy graduate Jorien Wiltenburg proposes
that consumers harvest their own waste metals. 'Copper mined from cables
... lends itself well to be used in its solid form through various weaving
techniques,' she says. 'This low-tech crafts work is in line with the self-
sustaining approach of the urban miner.'[5] And with Christy Matson (see
p. 164) already using copper wire as an alternative weft yarn, the idea doesn't
seem so far fetched.

Weaver Green makes rugs and textiles that look and feel like wool from
recycled plastic bottles and Swedish rug manufacture Kasthall has addressed
its own waste streams with its award-winning Harvest rug made from
left-over yarn. The high-end company makes spare yarn for every rug in case
of production issues. An extremely low tolerance for colour discrepancy
means that residual yarn cannot be reused, resulting in high levels of waste.
'The variation in colour posed a challenge and inspired us to find an exciting
way to put it to use,'[6] says in-house designer Ellinor Eliasson, who came up
with the solution. Kasthall now sorts the unused yarn into six approximate

5 Franklin, K. and Till, C. (2018) *Radical Matter: Rethinking Materials for a Sustainable Future.*
 London: Thames & Hudson: 37

6 Christie, M. (2017) 'Harvesting the Studio' in *The Ruggist*
 Available online: www.theruggist.com/2017/05/harvesting-the-studio-kasthall.html

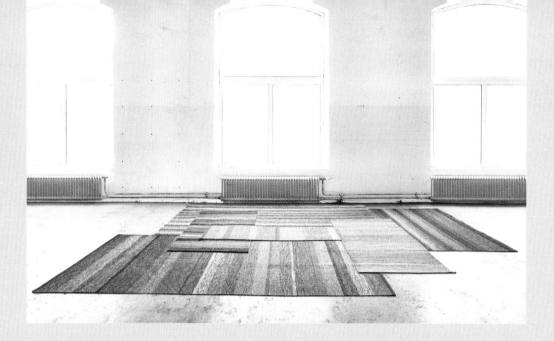

colour groups: green, grey, red/yellow, pink/purple, blue and brown/beige.
These are loaded onto 3-shuttle looms and used to weave the Harvest
collection – when one spool ends, a new colour is added, creating a different
pattern every time. Even the weavers themselves don't know what the rug
will look like until they take it off the loom. Rugs are made to order, and
customers have embraced the spontaneity of the process.

However, the circular economy is about more than simply using waste as a
raw material; it is about designing end-of-life reuse into products from the
beginning. Leading circular-design thinker Kate Goldsworthy is pioneering
the use of 'monomaterials' that are more easily recycled than fabrics that
blend multiple types of yarn, known to recyclers as 'monster' materials. Her
work involves manipulating the surface of polyester (arguably easier on the
environment than water- and labour-hungry natural alternatives) without
the use of secondary materials, toxic chemicals or adhesives, which reduce
recyclability. Because polyester is a thermoplastic, she is able to use a new
laser technique pioneered by scientists at The Welding Centre in Cambridge
to create surface patterns and composite materials without introducing
additional materials. Goldsworthy's 'Zero Waste Dress' is the first prototype.
Made using a one-step digital process (saving water, energy and chemicals),
it produces zero waste, and as a monomaterial it can be fully recycled without
any loss of quality at the end of its life.

⊕ Harvest Collection by Swedish carpet house Kasthall, 2017

Circumnavigating the issue of diminishing resources altogether, innovations in biotechnology are enabling weavers to grow their own materials that will naturally decompose at the end of their lives. Jen Keane (see following pages) is part of the Material Futures master's programme at London's Central Saint Martins and she is creating high-performance natural materials that are woven with bacteria. 'I started looking at the k. *rhaeuticus* bacterium that grows nano-cellulose – on a fibre level it is eight times stronger than steel and stiffer than Kevlar,' she says. 'It grows tiny fibres, so essentially it's weaving. I create the warp and it creates a mesh of fibres for the weft.' As her fabrics aren't traditionally woven, she can place the warp in any direction and the bacterium grows cellulose 'weft' into the gaps. 'What's interesting about that from a design perspective is that you can weave in any direction and create whole pieces,' she explains. 'Because textiles are stronger in the direction of the warp, I can create strength in any direction.'[7]

Whether eliminating or repurposing waste, saving lives or preserving the planet, it's clear that weaving – a practice as old as civilisation – still contains endless and sometimes surprising opportunities for innovation, not only as a pure craft form, but interlaced with numerous other fields of human endeavour. The fundamental combination of warp and weft remains constant but, as our technologies advance and our thinking evolves, the possibilities it creates – those 'gifts for the future' – are manifold and inspiring.

7 Interview with the designer, 19 April 2018

⊤ 'Zero Waste Dress', **Kate Goldsworthy** and **David Telfer**, 2014. Laser-finished, laser-cut and laser-seamed in 100% recycled and recyclable polyester

JEN KEANE

Jen Keane (California, United States, 1989) is pioneering what she calls 'microbial weaving' in which she lays down the warp and facilitates the creation of the weft by micro-organisms such as bacteria and yeast, optimising the natural properties of bacterial cellulose and creating 'a new category of hybrid materials that are strong, lightweight and potentially customisable to a nanoscale'.

With a background in the fashion and sportswear industry designing and developing performance textiles, she is now at London's Central Saint Martins on the Material Futures MA programme. 'We have a material problem,' she says. 'According to the Ellen MacArthur Foundation, there will be more plastic than fish in our oceans by 2050, and a lot of that comes from petrochemical-based synthetic textile fibres.' The problem, particularly in sportswear, is that natural fibres just can't deliver the same performance as synthetic fibres, and we no longer have the land, water or human resources to grow cotton, wool and silk at the scale of the synthetic fabrics we now use. 'There

are great efforts already in place at the moment to recycle these materials and become more circular,' says Keane. 'But you cannot recycle indefinitely – eventually these polymers degrade into the environment or into a form that is difficult to re-use.'

To solve this problem, Keane is trying not only to use biotechnology to replace existing high-performance fabrics, but to go one step further and find new ways of manufacture that might even out-perform them. 'Because the bacteria are so small, you don't have the same restrictions of directionality that you would have with a traditional loom,' she explains. Fabric is strongest in the direction of the warp – if the warp can be multidirectional, the strength can be too. My material currently still has a lot of the traditional problems of bacterial cellulose, in that it is very hydrophilic and so it gets slimy when wet. 'If we could start to grow other fibres into the matrix, we might be able to control this. The really interesting part will come when we can better control the types of fibres the microbes produce and how and where they grow them.'

It would be great to say, 'Let's just switch back to traditional natural fibres like cotton, wool and silk,' but it's not realistic. In some applications they could work, but we simply don't have the land or resources to grow enough of them to replace the sheer volume of synthetics that we use now.

I really had to develop my whole process from scratch so I have designed and built my own small 'microbial handlooms'. Working with living organisms, you need to be really careful to keep things sterilised to keep out unwanted invaders. I can only use certain materials like glass, stainless steel and some plastics.

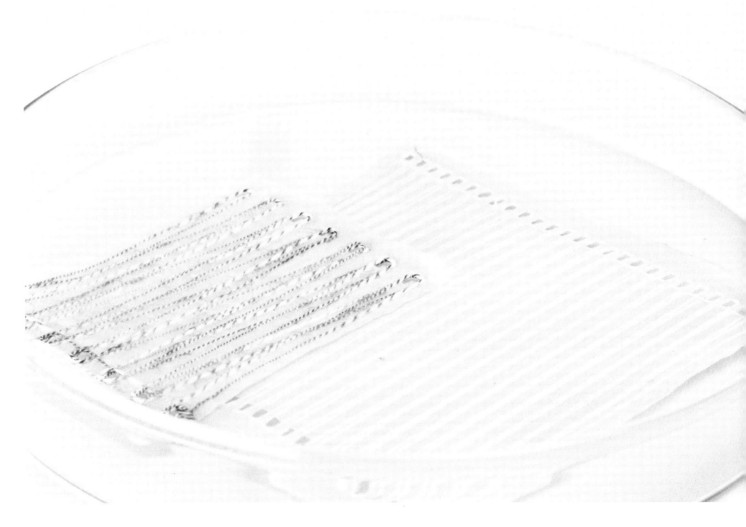

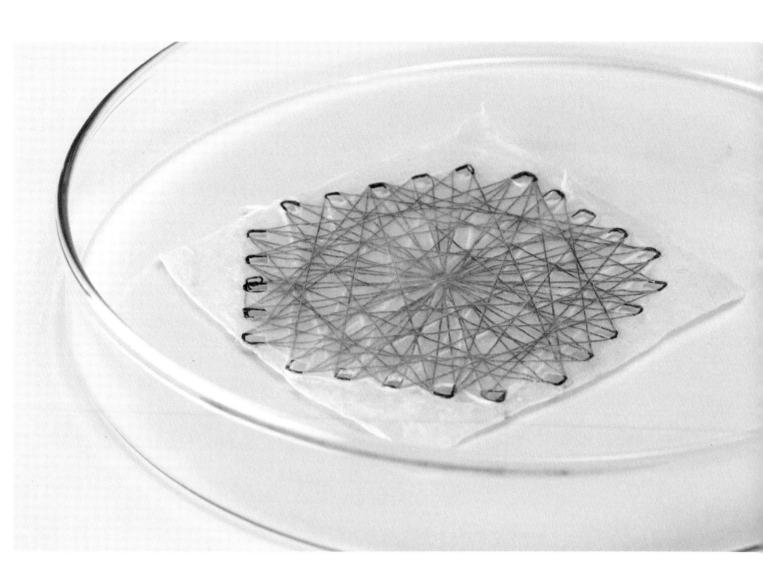

I am a designer but definitely not in the traditional sense. My work is at the intersection of design, craft, and science. The role is evolving and designers are becoming more like choreographers, bringing together the previously disconnected worlds of biology, computer science, aesthetics, and culture, to write new narratives for the future.

JEN KEANE

ILSE ACKE

Acke weaves fashion and home accessories such as scarfs and tablemats as well as artworks, using natural yarns such as wool, cotton and linen as much as possible. 'Sometimes I fall in love with yarn because of its colour or texture, so sometimes a synthetic or mixed yarn sneaks in,' she says. 'I try to learn every time I weave something, so I use a lot of different techniques, but constraints make me thrive, so weaving a cloth in linen binding and making it interesting and surprising for the viewer is a good task for me.'

Acke increasingly defines herself as an artist. 'My weavings are stories in thread,' she says. 'I want to surprise people and break boundaries. When I started weaving I was convinced I was a craftsperson, but that feels too restricting now. As the years go by I feel more and more of an artist – my stories are more important than the way I tell them.'

The first time Ilse Acke (Bruges, Belgium, 1975) sat down behind a loom was a life-changing moment. 'I was just trying out the machine, but it was like fireworks,' she says. 'From that very first moment I knew weaving was what I wanted to do.' In a period of flux, she had quit a graphic-design career to retrain as a fashion designer, but that moment set her on a new path. 'I immediately stopped my fashion studies and signed up for a part-time course in hand-weaving instead.'

Today she makes her living as a designer for a textile-printing company, and weaves during evenings and weekends. 'That was a conscious choice,' she explains. 'I do not want to ruin the fun of having freedom in my work by the pressure of earning enough money every month.'

Working across three looms, one with four shafts, one with 16 and a computer-driven loom with 24,

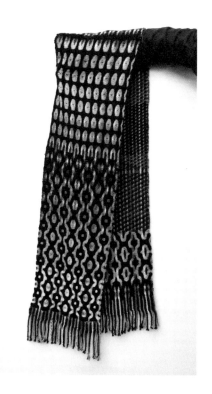

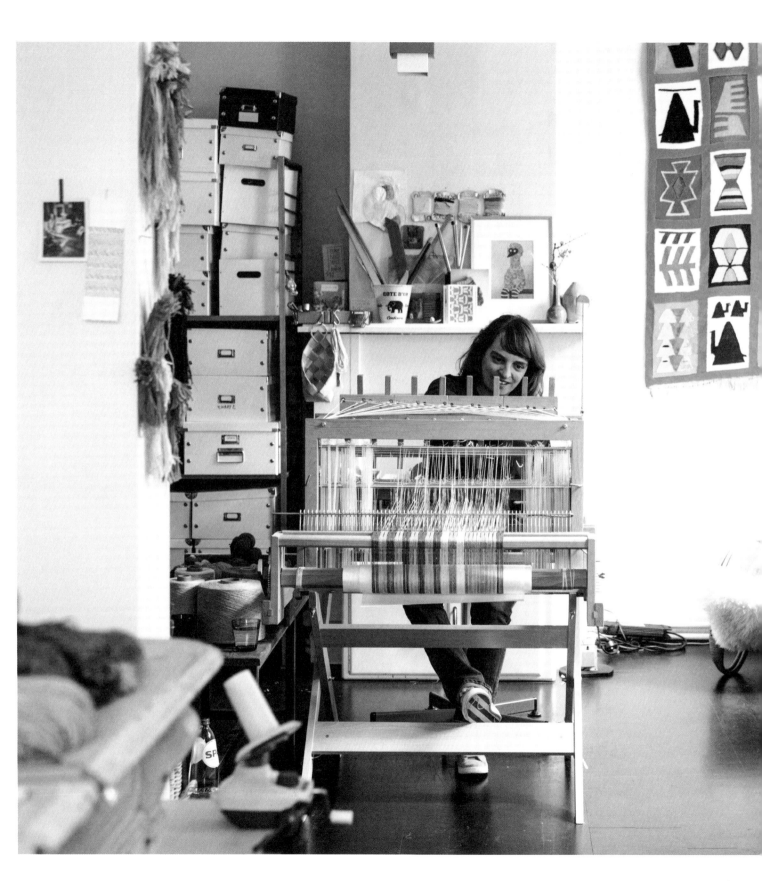

My weaving never starts with images. I never use moodboards. I collect materials and they start to tell a story. It is all about feeling, combining, and starting with a mood. It's about experience and what comes out of my head and fingers.

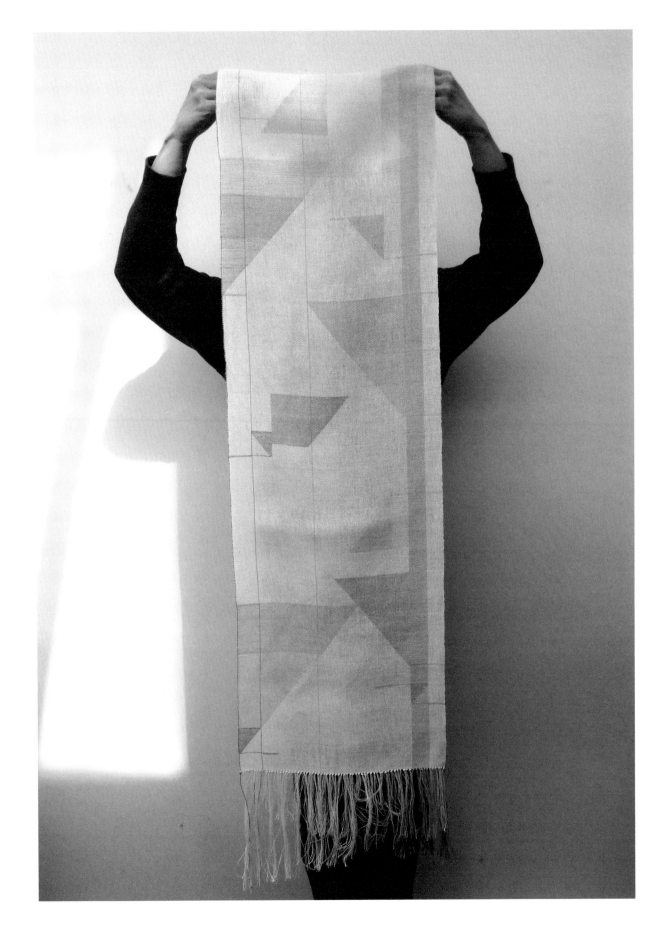

ILSE ACKE

My yarn collection comes from nowhere and everywhere. In the beginning I was working in a weaving mill, so I could get material there. I buy a lot of yarn from flea markets and when I'm travelling too, because that gives a unique character to my designs. When the yarn is gone, you can never find the same one again. I am always on the lookout for the perfect colour, that soft feeling...

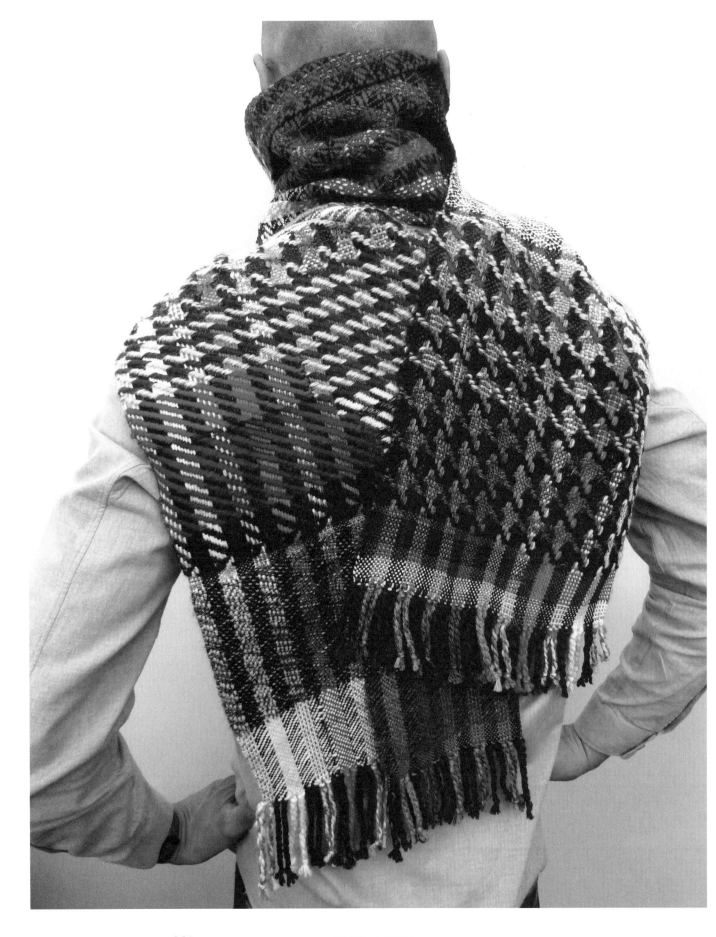

ILSE ACKE

KAYLA MATTES

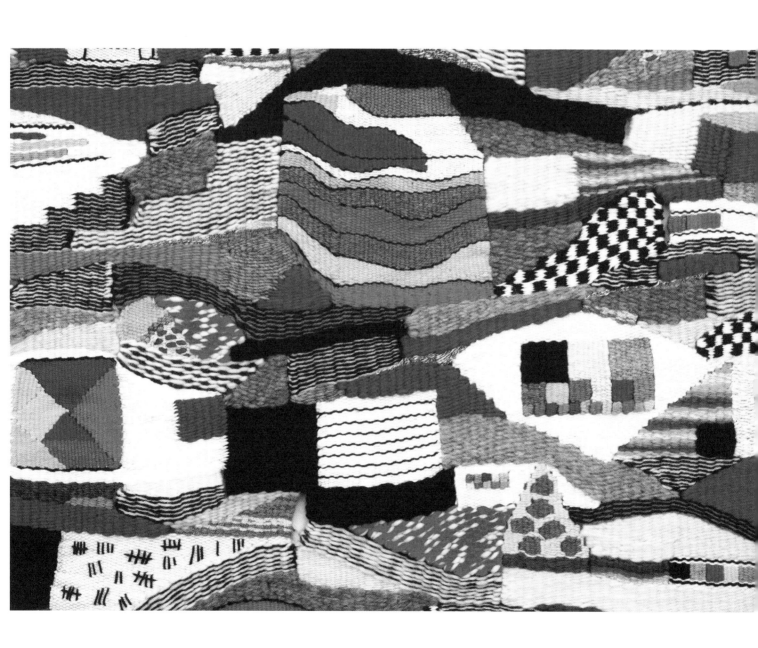

Kayla Mattes (California, United States, 1989) uses the connections and contradictions between weaving and the digital world as the starting point for tapestries that document the changing culture within cyberspace. In this way, she is part of a long and worldwide tradition of weavers who have used the medium as a means of archiving history through woven symbols – the language of the loom. 'Looms and computers both use binary systems – there's a rich relationship between the two that makes weaving the perfect medium to translate the visual culture of the digital world into physical material,' she says. 'We use textile-based words such as "net" and "web" to describe the internet because both are about connectivity.'

She is fascinated by how quickly we have learned to adapt to the new visual languages of the internet. 'I am creating artefacts that map the vernacular and the folklore of the digital world,' she explains. 'I transcribe these bits of information, slowing them down with the thread.' Having previously worked in the abstract, she is currently exploring more representative work as part of an MFA programme at the University of California Santa Barbara, inspired by the work of mid-20th-century Norwegian tapestry weaver Hannah Ryggen. 'I have been getting back into pictorial weaving that meshes together the languages of the web with overtly political messages,' she says. 'Ryggen made political anti-fascist tapestries during Hitler's regime and anti-war tapestries during the Vietnam war that also contained a certain level of abstraction.'

Despite the contemporary nature of her content, Mattes' methods are fairly traditional. 'Even though my work is inspired by technology, I am repelled from working solely with digital media,' she says. 'I always want to have a hand in the manipulation of thread on the loom.' She uses a 2-harness upright Leclerc Tapestry loom, a 4-harness Harrisville loom and a combination

of yarns including cotton, wool and bamboo to create weft-faced tapestries (in which the warp is completely covered by the weft), sketching out basic ideas before she begins. 'I'm also starting to bring other simple weave structures such as twills into my pieces in conjunction with plain weave,' she says. 'I'm interested in pushing simple parameters of weaving to make new discoveries.'

I'm drawn to the connection between looms and computers. Both use binary systems: zeroes and ones. The Jacquard loom preceded early punch-card computing and influenced the development of such technology. There's a rich relationship between looms and computers, which makes weaving the perfect medium to translate the visual culture of the digital world into physical material.

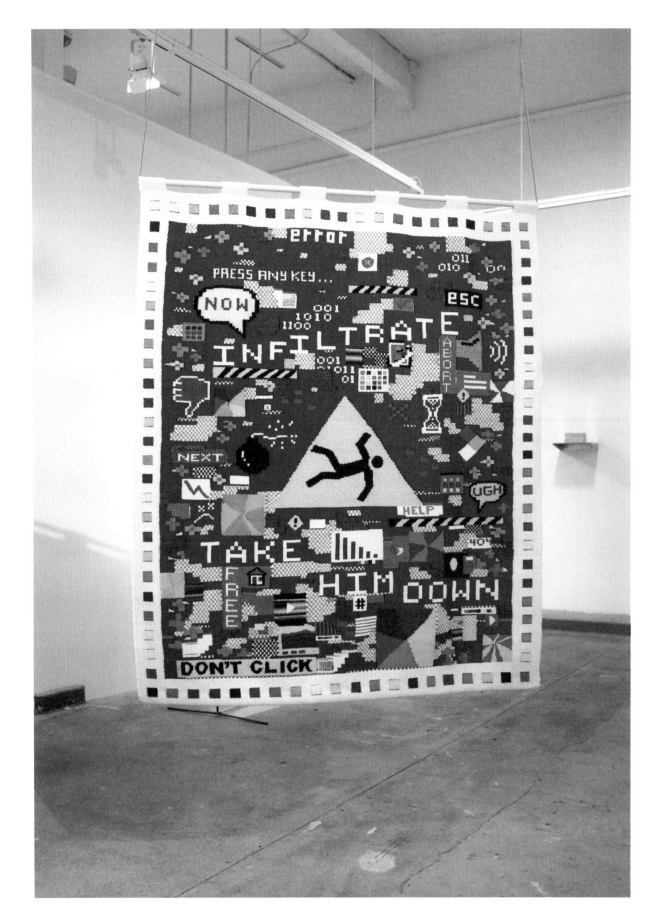

KAYLA MATTES

I see myself as an artist who weaves. There's a lot of historical baggage regarding the separation of art and craft: a split that's definitely tied to gender. I believe that craft and art are interchangeable and influence each other. Weavers are artists and artists can weave or employ all types of craft-based processes in their work.

ALLYSON ROUSSEAU

piece series and submitting it to my drawing professor.' Perhaps unsurprisingly, she struggled to convince him that her weavings should be considered as drawings.

Today Rousseau creates all her work on a self-made loom, using second-hand yarn, a basic steel weaving or thick, blunt sewing needle, whichever scissors she has to hand, a measuring tape and a plastic comb. 'It's important to me to keep my practice environmentally sustainable,' she says. 'By purchasing fibres second-hand, I keep my expenses down and get colour selections I might not find new. That's exciting because it means I may only be able to use certain colours once and then they are gone for ever.' Rousseau works without drawings, translating the shapes and forms she sees all around her straight onto the loom. 'I have always used the same few techniques in my work because I want to fully explore the possibilities that something so simple can yield,' she says. 'The moment I discover everything is working in a piece – when the balance of positive and negative space feels just right – is wonderful. It feels like *déjà vu*, reaffirming that I have chosen the right path for my life. Weaving might be a risky choice of career, but it is one of the most rewarding things you can do; with your time and with your hands.'

Allyson Rousseau (Montreal, Canada, 1993) weaves small-scale wall hangings on a handmade lap loom in her home studio. A background in fine art informs her aesthetic, which is inspired by Modernist painting and graphic design. 'The purpose of my work is to explore the possibilities of composition: shape, form, colour, balance, tension, space and texture,' she says.

Rousseau discovered contemporary weaving through the work of Korean-born LA-based artist Mimi Jung in the final year of her degree at Guelph University – the first time she had seen weaving used in contemporary art. 'Something clicked, and I began experimenting with fibre immediately,' she says. Unfortunately, her department didn't run textiles courses, so she taught herself through exploration and experimentation. 'It wasn't easy, but I am grateful I began my practice as I did,' she says. 'I fumbled around getting to know the tools and the process, soon weaving a four-

For the most part, the current 'weaving scene' is saturated with people who are learning how to weave as a hobby craft. There is a divide between weavings that are considered 'craft' and those that are considered 'art'. But, because it's all happening over the internet, they tend to blend together as one.

213 ALLYSON ROUSSEAU

I rarely begin by sketching out the details of a design. I start with the idea in my head, and create from there. The most reliable way for me to verify the success of a design is to start building it with my hands, and work by the process of elimination as I get to know it in physical form.

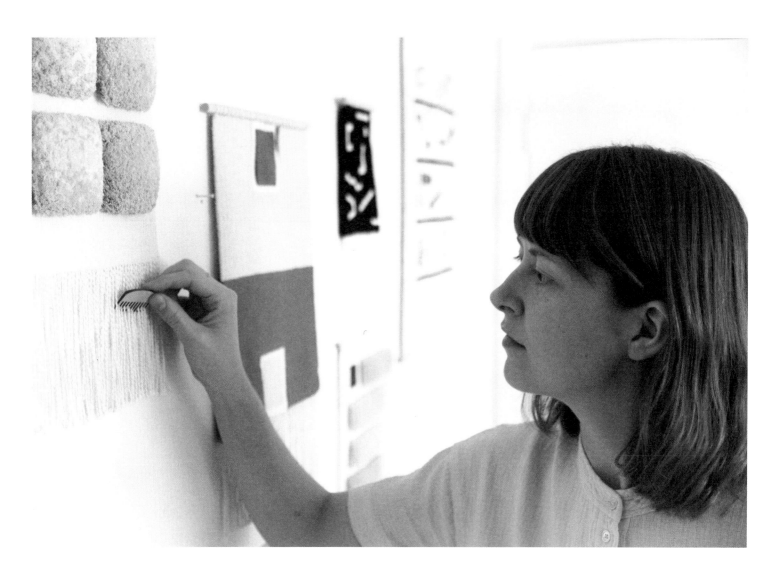

Most of my ideas stem from fairly mundane things; simple shapes and forms, things found in nature, street signs, posters – anything that stands out as having an interesting balance of form, space, and colour. I don't find inspiration easily if I am looking for it – for the most part inspiration finds me.

ALLYSON ROUSSEAU

ACKNOWLEDGEMENTS

'A single conversation with a wise man is worth a month's study of books'
— CHINESE PROVERB

I have, of course, in the process of researching this book tried my hand at weaving and gained some insight into both the mechanics and the allure of the craft, but I make no pretence of being a practitioner, let alone an expert. This book is the result of months of research involving long days in the library consulting endless books and journals, but – perhaps more illuminatingly – many conversations with people who make their living from weaving. I am incredibly grateful to those wonderful 'connectors' who helped me find those weavers, and to each and every one of my newly formed panel of experts for their generosity of time and knowledge, their belief in my ability to write this book and their words of encouragement when I felt that belief might be more than a little misguided. I am especially appreciative of those patient souls who read my first drafts; their insightful feedback shaped my words into the book you hold in your hands. I am, as always, most grateful of all to my unfaltering husband, who keeps the show on the road every time I disappear into a project like this one, emerging only occasionally to demand food or sleep. Thank you.

My humblest and most heartfelt thanks to all the weavers profiled in the book, and to Anthony Leyton, Audrey Durrant, Caroline Till, Dorothy Bourne, Edmund Le Brun, Ella Doran, Jennifer Isles, Jess Meyer, Joanna Robinson, Jodi Moss, Leyton Allen-Scholey, Lily Tennant, Mario Sierra, Matthew Bourne, Philippa Brock, Reto Aschwanden, Robert Durrant, Robert Treggiden, Ruth Ruyffelaere and Sabine Zetteler. I couldn't have done this without you – and wouldn't have wanted to. Thank you.

KATIE TREGGIDEN

READING LIST

Anon. (2011) 'Self Assembly – Philippa Brock'.
Available online: onviewonline.craftscouncil.org.uk/4040/object/T173

Adamson, G. (2007) *Thinking through Craft*. London / New York: Berg.

Adamson, G. (2010) (ed.) *The Craft Reader*. Oxford: Berg.

Adamson, G. (2013) *The Invention of Craft*. London: Bloomsbury.

Adamson, G. (2016) *Crafts Book Club*.
Available online: craftscouncil.org.uk/articles/crafts-book-club-glenn-adamson

Albers, A. (2003) *On Weaving*. (3rd ed.) New York: Dover Publications Plc.

Christie, M. (2017) 'Harvesting the Studio' in *The Ruggist*.
Available online: www.theruggist.com/2017/05/harvesting-the-studio-kasthall.html

Franklin, K. & Till, C. (2018) *Radical Matter: Rethinking Materials for a Sustainable Future*. London: Thames & Hudson.

Ginsburg, M. (1991) *The Illustrated History of Textiles*. London: Studio Editions.

Goggin, M. and Tobin, B. (2016) *Material Women, 1750–1950*. Abingdon: Routledge.

Harris, J. (1993) *5000 Years of Textiles*. London: British Museum Press.

Markowitz, S. (1994) 'The Distinction between Art and Craft' in *The Journal of Aesthetic Education*. 28:1: 55–70.

Mcdonough, W. and Braungart, M. (2002) *Cradle to Cradle: Remaking the Way We Make Things*. New York: Farrar, Straus and Giroux.

Müller, U. (2009) *Bauhaus Women*. Paris: Flammarion.

Pallasmaa, J. (2012) *The Eyes of the Skin: Architecture and the Senses*. Chichester: John Wiley & Sons.

Parker, R. and Pollock, G. (1981) *Old Mistresses*. New York: Pantheon.

Pedersen, S. (2000) 'The Future of Feminist History' in *Perspectives on History*.
Available online: www.historians.org/publications-and-directories/perspectives-on-history/october-2000/the-future-of-feminist-history

Pye, D. (1968) *The Nature and Art of Workmanship*. Cambridge: Cambridge University Press.

Schwarzkopf, J.D. (2004) *Unpicking Gender: The Social Construction of Gender in the Lancashire Cotton Weaving Industry, 1880–1914*. Abingdon: Ashgate Publishing Ltd.

Sennett, R. (2008) *The Craftsman*. London: Penguin Books.

Simpson, L.E. (1978) *The Weaver's Craft*. Leicester: Dryad Press.

Smith, T. (2014) *Bauhaus Weaving Theory: From Feminine Craft to Mode of Design*. Minneapolis: University of Minnesota Press.

Sutton, A. and Sheehan, D. (1989) *Ideas in Weaving*. London: Batsford.

Treggiden, K. (2014) 'Oluwaseyi Sosanya invents 3D-weaving machine' in *Dezeen*.
Available online: www.dezeen.com/2014/06/23/oluwaseyi-sosanya-invents-3d-weaving-machine-show-rca-2014/

PHOTOGRAPHIC CREDITS

Ilse Acke: pp. 194, 195, 196–197, 198, 199, 201

Agencia EFE: p. 182

Courtesy Studio Tanya Aguiñiga: pp. 104, 106, 107, 108–109, 110, 111

Anni Albers Estate © SABAM Belgium 2018: p. 56

Jenna Bascom, Courtesy Museum of Arts and Design, New York: p. 105

Bauhaus-Archiv Berlin: pp. 48, 52, 58, 130, 131; © Estate of T. Lux Feiniger: p. 55; © Atelier Schneider: p. 133; © VG Bild-Kunst, Bonn 2016: pp. 53, 132

Philippa Brock: p. 181

Danny Burrows Photography — www.dannyburrowsphotography.com: pp. 70, 71, 72, 73, 74, 75, 76–77

Lauren Chang: pp. 98, 100, 101, 103

Nick Colony: pp. 147, 148, 155

Guillaume Couche: p. 180 (bottom)

Eefje De Coninck: pp. 38, 46, 47

Dienke Dekker: p. 161

Christophe Derivière: pp. 39, 40, 41, 42, 43, 44–45

Cornelia Gardner: p. 165

Kate Goldsworthy: p. 187

Emiliano Granado: pp. 60, 62–63

Genevieve Griffiths: pp. 31, 35, 36

Jeff Hargrove: pp. 79 (bottom left), 82

Matt Harvey: pp. 22, 25

Juno: p. 156

Judit Just: pp. 120, 121, 123, 124

Kasthall: p. 186

Jen Keane: pp. 188, 192, 193

Kinnasand: pp. 157, 163

Klassik Stiftung Weimar: p. 135

Rigetta Klint: pp. 78, 79 (top)

Adam Krause: pp. 26–27

Dorte Krogh: p. 79 (bottom right)

Jennifer Marx: pp. 20, 21

Christy Matson: pp. 164, 166, 167, 168, 169, 170

Maya Matsuura: cover, pp. 80–81

Kayla Mattes: pp. 202, 203, 204, 205, 206–207, 208

Francisco Nocito, Courtesy Alexandra Kehayoglou Studio: pp. 61, 65, 66–67, 69

Brad Ogbonna: pp. 85, 86, 87, 89

Courtesy Peres Projects, Berlin, photography Trevor Good: pp. 136, 137, 138, 139; photography Matthias Kolb: pp. 140, 141, 142–143, 144, 145

Justin Pip: p. 112

Eleanor Pritchard: pp. 4, 9, 10, 13, 172, 173, 174, 175, 176, 177

Erin M. Riley: pp. 84, 88

Allyson Rousseau: pp. 210, 211, 212, 213, 214, 215, 216, 217

Marta Sasinowska: pp. 14, 15, 16, 17, 18–19

Iona Scott: pp. 113, 114, 116, 117, 119

Rachel Snack: pp. 146, 150–151, 152, 153, endpapers

Hiroko Takeda Studio: pp. 23, 24, 29

Alan Tansey: p. 28

Eduardo Torres, Courtesy Alexandra Kehayoglou Studio: p. 64

Adam Toth: pp. 189, 190, 191

Turquoise Mountain: pp. 90, 94

Lonneke van der Palen: p. 158

Roos van Leeuwen: p. 160

Jake Walker: pp. 30, 32–33, 34

Zuzanna Weiss: p. 180 (top)

Jorien Wiltenburg: pp. 178, 184, 185

The hand-drawn illustrations in the introduction are by Lily Tennant.

223

COLOPHON

Text
Katie Treggiden

Editing
Ruth Ruyffelaere

Text Editing
First Edition Translations Ltd.

Graphic Design
Dylan Van Elewyck

Production
Emiel Godefroit

Printing
DeckersSnoeck

ISBN 978-94-9181-989-6 (Europe)
D/2018/6328/8

ISBN 978-1-4197-3380-2 (US)
Distributed in the US and Canada by Abrams,
an imprint of ABRAMS.

Printed and bound in Belgium.
Published by Ludion.

Ludion
Leguit 23
2000, Antwerp, Belgium
info@ludion.be | www.ludion.be

LUDION

Katie Treggiden is a craft and design journalist with almost twenty years experience in the creative industries. She regularly contributes to publications such as *The Guardian*, *Crafts Magazine*, *Elle Decoration*, and *Design Milk*. This is her fourth book and second for Ludion, after the success of *Urban Potters*, which was published in September 2017. She is currently studying for her Masters in the History of Design at the University of Oxford.